IMAGES
of America

FAIRHOPE

D1225701

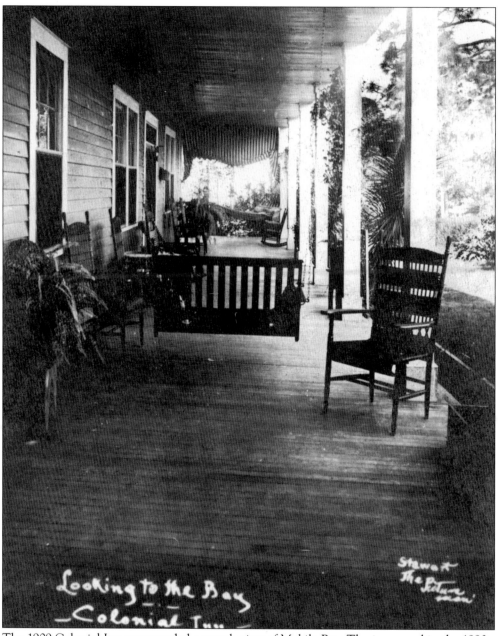

Looking to the Bay
—Colonial Inn—

Stewart
The Picture
man

The 1909 Colonial Inn commanded a superb view of Mobile Bay. The inn, razed in the 1990s, was a dining and social center in the village of Fairhope, which became a popular winter resort. The hotel that hosted visitors from across the country for decades was wrapped in spacious porches to catch the soft summertime Gulf breezes. (Courtesy Debbie Quinn.)

On the cover: Barefoot children enjoy the cool waters of Sweetwater Branch on the bay near Fairhope. The stream served as a source of fresh water for the settlement before the community well was put down in front of the colony general store. Even after that, old-timers remember trips to the branch as children when they rode on wagons with barrels to get sweet drinking water.

IMAGES
of America

FAIRHOPE

Cathy Donelson
With foreword by Fannie Flagg

Published by Arcadia Publishing
Charleston SC, Chicago IL, Portsmouth NH, San Francisco CA

Printed in the United States of America

Library of Congress Catalog Card Number: 2005931515

For all general information contact Arcadia Publishing at:
Telephone 843-853-2070
Fax 843-853-0044
E-mail sales@arcadiapublishing.com
For customer service and orders:
Toll-Free 1-888-313-2665

Visit us on the Internet at www.arcadiapublishing.com

The bluff overlooking Mobile Bay remains as much of a landmark today as it was when the first expeditions of conquistadors and European explorers sailed into the bay in search of a new world and treasure. One treasure they found turned out to be a world-class waterfront view in one of the most unusual small towns in America.

CONTENTS

FOREWORD

Nothing pleases me more than to be asked to write about Fairhope. I hope that after you read this marvelous book, you too will agree that Fairhope is a special place, with a unique history and an even more exciting future.

Perched high on a bluff, overlooking the beautiful Mobile Bay, Fairhope seems, to those of us who love it, just like Utopia. Not surprising, the town was founded by a group of people known as "The Utopians." Since then, Fairhope has gone on to become a haven to many artists and writers who have gathered here from all over the world and now make it their home. As they have found out, you can travel far and wide and not find a more perfect little town, and once you have been here, I promise you, you will never forget it.

I can still remember that summer evening in 1955 (long before the interstate freeway), when my family and I, headed for Gulf Shores, drove through Fairhope for the first time on old Highway 98. I was completely mesmerized by the magical look of the place—the lights in the trees casting dancing shadows on the ground as the Spanish moss blew gently in the warm breeze, the smell of the night blooming jasmine, the twinkling lights of Mobile sparkling like a jeweled necklace across the bay.

One look and Fairhope cast her spell on me. That night, I made a secret vow that one day I would return, and return I did. And now so many years later, whenever work or some other such foolishness, calls me away for too long, I find that secret invisible thread begins to pull at my heartstrings calling me back home.

You may very well wonder what it is about this place that affects all of us who love it so. I have asked myself that same question a hundred times. Is it the friendly people? The closeness of the community? The unique downtown shops, the delicious seafood? Or could it be the serene beauty and calmness of the bay, the fragrance of the wild honeysuckle, wisteria, and gardenia blooming in spring?

Is it the hundreds of majestic oak trees with Spanish moss hanging from every limb, or the tall pine and cedar trees that can be found all over town? Or the beautiful historic old homes that line the boardwalk by the Grand Hotel? The little Orange Street pier? The colorful sailboats across the water on a bright sunny day? The warm balmy winters when on Christmas day, more often than not, folks walk around in their shirtsleeves while our northern neighbors shovel snow?

Is it the large array of birds—red birds, blue birds, snowy-white egrets, blue heron, pelicans, and sea gulls—that live here year-round? The many parks where one can safely walk night and day? Is it the Art Walk all over town? The great bookstores? The fresh flowers that line every street? The outdoor band concerts in summer? Or could it simply be the magnificent sunsets on the bay every evening? The answer is yes, all this and much more.

Although I've done my best to describe it, the truth is, Fairhope is really a state of mind and cannot be explained by using mere words. It must be felt. So I'm giving you fair warning. Visitors and tourists beware: if you come here, you, too, just might fall in love with Fairhope and stay forever.

—Fannie Flagg

INTRODUCTION

Long before the English humanist and statesman Sir Thomas More published his *Utopia* in 1516, man dreamed of finding or establishing a perfect place.

Fairhope, a small town that has played a large role in American history, is the result of those kinds of dreams. The site of the model community founded from scratch on Alabama's Gulf Coast by visionaries in 1894 had been imagined as an ideal location for a city by many others before them.

Vintage views of the remarkable colony created out of their vision of a Utopian society are presented in the pages of this book, which conveys a special sense of time and place.

Utopia means "no place" in Greek. Ironically the founders of Fairhope had selected the name of their experimental colony in the late 19th century before they decided on a place for the town they thought would have a "fair hope" of succeeding.

Idealists and freethinkers from across the country who were devoted to the economic theory of a single tax on land pooled their resources to create an intentional community to demonstrate their ideals. They cast their fortunes and futures upon a forested bluff with a sweeping and panoramic view of the bay for their communal colony based on a concept of "cooperative individualism."

From the beginning of European exploration of the Gulf of Mexico, the inviting bluff on the Eastern Shore of the bay was part of a struggle for a New World empire. Spain first claimed the scenic region that early conquistadors believed held a fabled fountain of youth.

Alonso Alvarez de Pineda, an explorer who had sailed with Christopher Columbus, was the first to map the bay in 1519. Laying claim to the region for Spain, he named the bay Espiritu Santo, or Bay of the Holy Spirit.

Despite Spanish efforts to hold title to the lush stretch of semi-tropical coastline, it was the French who established a permanent settlement there. A colonization expedition sent by Louis XIV, the flamboyant Sun King, landed on a Gulf beach south of the future site of Fairhope in 1699 and built a fort upriver.

Mobile was established in 1711 and became the capital of old Louisiana, named in honor of King Louis. French plantations to supply the colony were located on the bluffs across the bay.

Two Canadian brothers, Jean Baptiste le Moyne, sieur de Bienville, and Pierre, sieur d'Iberville, led the expedition to settle the area to squeeze the rival British out of the Atlantic Coast where they had founded colonies.

In 1703, d'Iberville was named the first governor of French Louisiana. He asked the king for a grant of land around Mobile Bay, including the great bluffs on the Eastern Shore, but the crown refused. The rich land was intended to attract settlers from France.

D'Iberville's tenure as governor was short-lived. He died in Havana in 1706 while planning an invasion to drive the English from the Eastern Seaboard. If the plan had succeeded, it would have changed the course of American history.

The first recorded settler may not have arrived willingly at what is now Fairhope. Pierre Laurendine, a 21-year-old soldier, arrived in the Louisiana colony in 1727 on a ship listing its passengers as "Deserters and Others Sent by Order of the King."

He became a landowner and established a plantation on the Eastern Shore. After his death in 1769, his holdings passed to his son Jean Baptiste Laurendine.

Old Louisiana was dismembered after the Peace of Paris in 1763, when part of the area passed to Britain, essentially becoming a 14th colony, British West Florida. The two leading British officials of the province established plantations on prime lands north and south of Laurendine and laid out a new town there to supplant Mobile.

However, the Revolutionary War scuttled plans for their dream town on the Eastern Shore. In 1779, the British surrendered the area to Spanish forces.

In 1800, Laurendine, calling himself "an old inhabitant of this District," petitioned the Spanish commandant at Mobile for pastureland across the bay because, he said, an Appalachee tribe uprising placed him at risk of losing his cattle.

His request was granted, and in 1805, Laurendine sold his land, which also contained a house and kitchen, for $120 to Louis de Feriet of New Orleans. The French baron was a lieutenant with a Spanish regiment of Louisiana Infantry serving in Mobile.

The rest is history, illustrated by maps, drawings, and photographs contained in this book. The images tell the story of still another dream town, Alabama City, which was platted on the bluff. But yet another conflict, the Civil War, intervened. The site of Fairhope remained pine and pastureland until the so-called "single-taxers" arrived to create their model town.

Their creation became the oldest and largest single-tax colony in the world and the most successful.

The unique village drew progressives and Populists, Socialists and Quakers, artists and intellectuals, and even nudists and free-love advocates. Many of the major social reformers of the early 20th century—from Dewey to Darrow—made pilgrimages to Fairhope. Strong individualists, fine minds, independent spirits, and colorful characters of all sorts came to inhabit the town founded on principle.

Thanks go to all who treasure the mystique and magic of "Old Fairhope," especially those who shared their historic documents and heirloom photographs along with their memories of some of its forgotten people and places.

One

UTOPIAN DREAMS

*The second matter that I take the liberty of communicating to Your Lordship is the advantages
that will accrue to the Province of establishing a Town on the East side of the Bay of Mobile,
below a place called the Red Cliffs, as the unhealthy Situation of the present one
makes such a measure necessary.*

—Elias Walker Durnford, acting governor,
British West Florida, February 3, 1770

Fairhope hugs the Eastern Shore of Mobile Bay, where English officials envisioned a new seat of
government to supplant the old Colonial capital of Mobile, a fever-ridden bone yard for British
troops. Laid out with streets at oblique angles to take advantage of the fresh bay winds, this
visionary town remained a dream.

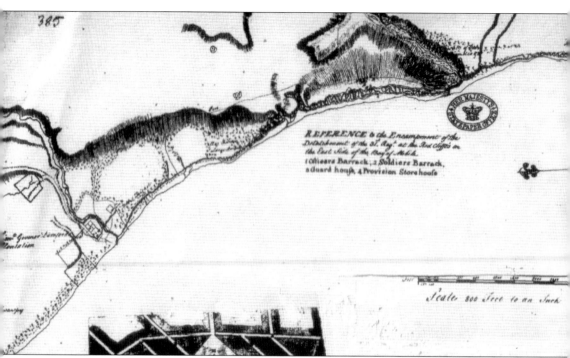

Elias Walker Durnford, royal surveyor and governor of British West Florida from 1769 to 1780, proposed a town where Fairhope lies today. Durnford and Edmund Rush Weggs, the attorney general of the province and owner of the plantation shown at the right of the drawing, offered to give up some of their Eastern Shore holdings for a town to replace Mobile. Durnford owned

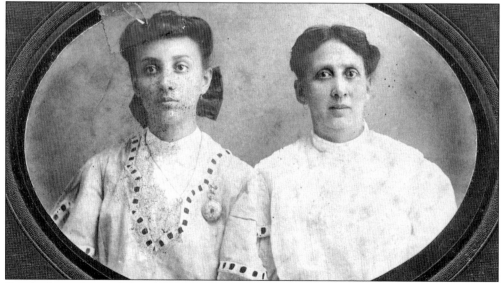

Creole descendants of the old French Louisiana founders first settled the Fairhope bay front. Martha Juzang (right) and daughter Olivet lived in an early settlement on Magnolia Beach where old Creole families still own land. One of their ancestors, Pierre Juzang, was the Spanish crown's commissary for American Indians in Mobile. He received one of Spain's first land grants in the region. (Courtesy Eleanor Harpe.)

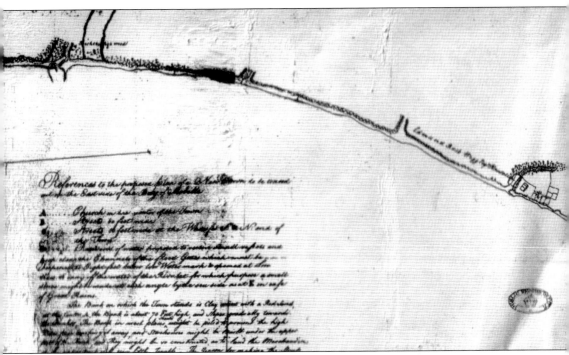

over 57,000 acres along the Gulf Coast, including a 5,000-acre plantation north of Fairhope. The Revolutionary War dashed Britain's hopes of establishing the new city. After the takeover by Spain, this area became part of Spanish West Florida.

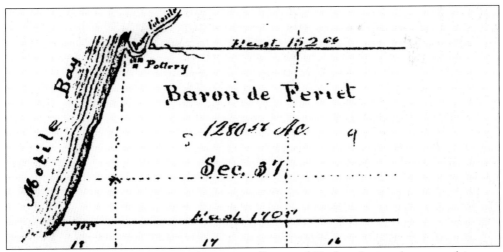

French settler Jean Baptiste Laurendine originally owned Fairhope's site, shown on this map. In 1805, Spain granted his abandoned plantation to Baron Louis de Feriet of New Orleans. De Feriet married the youngest daughter of Gilbert Antoine de St. Maxent, the richest Frenchman in all of old Louisiana, who controlled the trade along the Mississippi River. (Courtesy University of South Alabama Center for Archaeological Studies.)

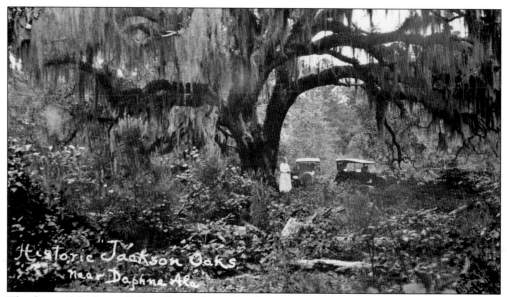

The historic Jackson Oak still stands in Daphne near Fairhope. Andrew Jackson climbed the legendary landmark in 1814 to rally 3,000 troops to occupy Mobile, thus ending Spanish Colonial rule in the region. "Old Hickory" then moved on to defeat the British in the Battle of New Orleans. What is now Fairhope became American territory for the first time after the War of 1812. (Courtesy Palmer Hamilton.)

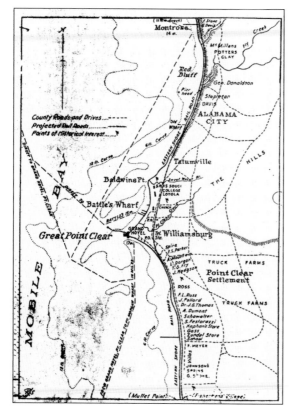

In the 1830s, a group of wealthy speculators headed by famed New Orleans developer Laurent Millaudon next dreamed of a planned town where Fairhope is today. They purchased the de Feriet tract to establish Alabama City. An early map of part of the Baldwin County shoreline not only shows Alabama City, but also indicates an Eastern Shore Railroad, which was never constructed.

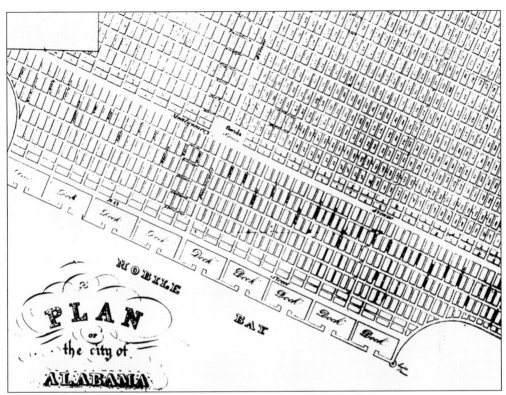

A plat of Alabama City shows a seaport laid out on a plan similar to Savannah, with wharves, named streets, and spacious squares. Several of the 10,000 lots were purchased in sales in Mobile and Montgomery, but the new town that developers hoped would someday rival Mobile across the bay never got off the ground.

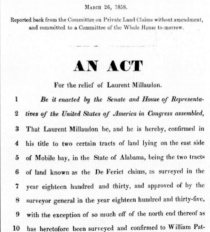

35TH CONGRESS,
1ST SESSION.

S. 81.

[H. Report No. 219.]

IN THE HOUSE OF REPRESENTATIVES

MARCH 26, 1858.

Reported back from the Committee on Private Land Claims without amendment, and committed to a Committee of the Whole House to-morrow.

AN ACT

For the relief of Laurent Millaudon.

1 *Be it enacted by the Senate and House of Representa-*
2 *tives of the United States of America in Congress assembled,*
3 That Laurent Millaudon be, and he is hereby, confirmed in
4 his title to two certain tracts of land lying on the east side
5 of Mobile bay, in the State of Alabama, being the two tracts
6 of land known as the De Feriet claims, as surveyed in the
7 year eighteen hundred and thirty, and approved of by the
8 surveyor general in the year eighteen hundred and thirty-five,
9 with the exception of so much off of the north end thereof as
10 has heretofore been surveyed and confirmed to William Pat-
11 terson, and included within what is known as the Patterson
12 claim, as now located: *Provided,* That this act shall only
13 be construed as a relinquishment of any title that the United
14 States may have to said lands: *And provided, further,* That
15 this confirmation shall enure to the benefit of any other per-

In 1858, Congress confirmed Millaudon's claim to the Alabama City property. Years earlier, Congress also had empowered the influential developer to dig a canal on Canal Street in New Orleans. The Civil War defeated his plans for Alabama City, and in the 1870s, Millaudon's heirs sold the Alabama tract to area families in a courthouse sale.

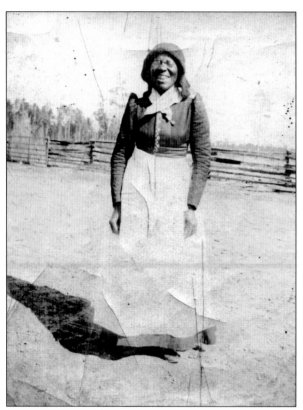

Ellen Hill, a former slave who became one of Fairhope's best-known and most beloved residents, was one of the few people living in the vicinity after Alabama City failed to materialize. She and her family lived on a bluff overlooking the bay at Sea Cliff. Mischievous local youngsters brought chickens they had stolen to "Aunt Ellen" to fry for them. (Courtesy Flora Maye Simmons.)

For many years, the swift side-wheeler *Heroine* brought passengers "over the bay" from Mobile to elegant Eastern Shore summer homes and resorts. The famed *Heroine* (pronounced Hero-ine by Fairhope old-timers) was built in Scotland for running the blockade during the Civil War and later used as a Confederate ambulance ship. Around 1890, she was converted into a passenger steamer. (Courtesy Ken Niemeyer.)

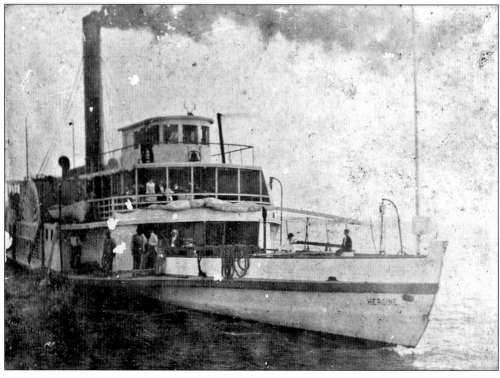

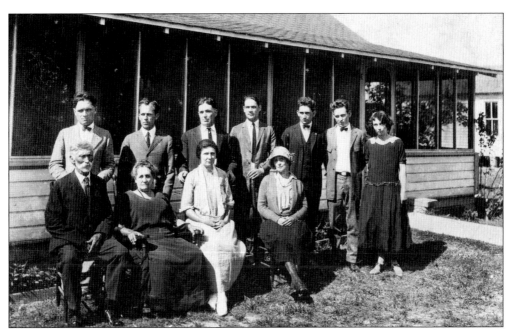

The Nelsons and Lowells were early Baldwin County settlers. From left to right, are (seated) Martin Luther and his wife, Ann Nelson Lowell, aunt Blanche, and daughter Pearl; (standing) Martin and Ann's other children—Grover, Hugh, Luther, Orrie, Gordon, Clyde, and Diamond. Many of them became the town's businessmen, bakers, and barbers after Fairhope was founded. (Courtesy Florence Lowell Kellogg.)

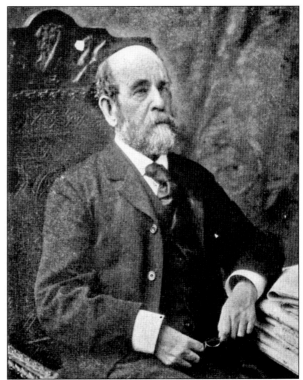

Henry George was the influential 19th-century economist whose "single tax" philosophy was the moving spirit behind a group of idealists, many from Iowa, who would settle Fairhope. Their social experiment was based on his theories, inspired by his 1879 book *Progress and Poverty*, which espoused a single tax on land, regardless of improvements.

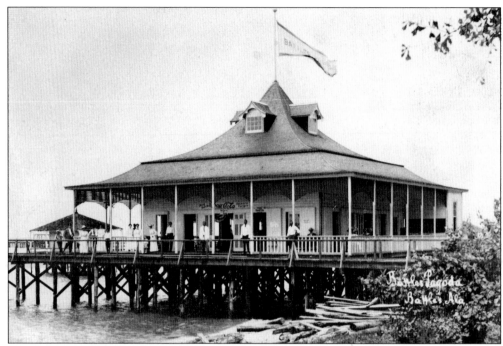

A group of 28 settlers, including nine children, arrived at Battles Wharf in November 1894 to establish a cooperative colony. The site of the egalitarian town they planned to build on the bay was nearby to the north. Soon after Fairhope was founded, the wharf sported the Battles Pagoda, where visitors could dine and dance on the bay. (Courtesy Palmer Hamilton.)

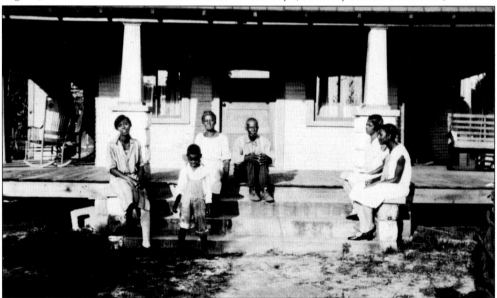

The colonists bought land that held the cabin and farm of former slaves John Henry Lewis and his wife, Nancy, who figures prominently in the book *Women of Fairhope* by historian Paul M. Gaston. The Lewis family relocated; here one of the Lewis sons, Alfred, his wife, Rosetta Young Lewis, and their children relax on the porch of the later family homestead still standing on Ingleside Avenue. (Courtesy Rosetta Wasp.)

Jerome B. Stapleton was an early Baldwin County settler who, along with his brothers, owned what was called Stapleton's Pasture, where they raised beef cattle on a bluff above Mobile Bay. Their waterfront tract makes up the core of old Fairhope. The single-taxers, who pooled their modest resources, paid $6 an acre for their planned community. (Courtesy Jack Stapleton.)

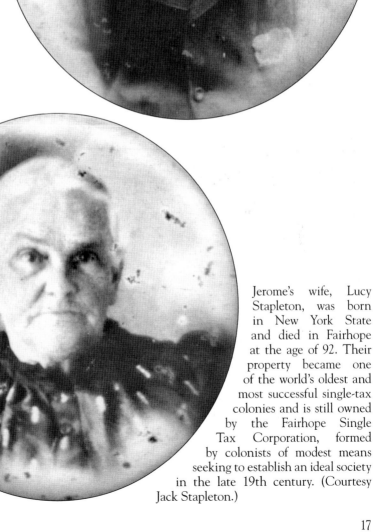

Jerome's wife, Lucy Stapleton, was born in New York State and died in Fairhope at the age of 92. Their property became one of the world's oldest and most successful single-tax colonies and is still owned by the Fairhope Single Tax Corporation, formed by colonists of modest means seeking to establish an ideal society in the late 19th century. (Courtesy Jack Stapleton.)

Only winding wagon lanes, like this one along Fly Creek, crossed the property the settlers chose to start their communal experiment, selecting their site for its beauty and cheap land. Originally called Bayou Volanta by the French, the picturesque creek marked the northern boundary of the town until the 1990s. (Courtesy Rusty Godard.)

Two

A "Fair Hope"

To those who, seeing the vice and misery that spring from the unequal distribution of wealth and privilege, feel the possibility of a higher social state and would strive for its attainment.

—Henry George, *Progress and Poverty*, 1879

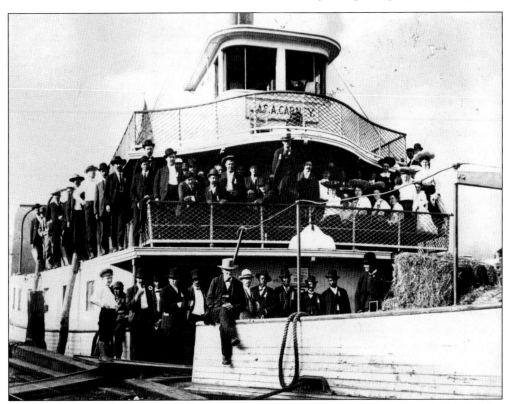

The founders named their town Fairhope before it existed because they reckoned it had a "fair hope of success," and they invited a "class of clear-headed and true-hearted reformers" to join their venture to demonstrate Henry George's theories. Here passengers arrive on the steamer *James A. Carney*, which brought the first settlers from Mobile, where they had come by rail with all their possessions. (Courtesy Helen Dyson.)

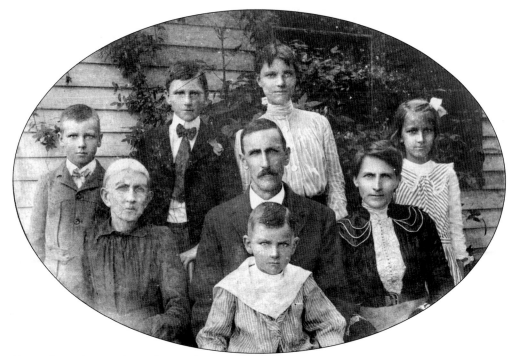

Ernest Berry Gaston (seated second row center), a young idealist and a founder of the Fairhope Single Tax Corporation (FSTC), brought his wife, Clara Mershon (seated right), mother (seated left), and family from Des Moines, Iowa, to start the experimental colony on Mobile Bay. The children, standing from left to right, are Cornelius, James Ernest, Frances Lilly, Leah Catherine, and Arthur Fairhope "Spider" (seated front center), the first white boy born in Fairhope. (Courtesy FSTC.)

The utopian settlement started with houses for the first five families and a store, with the goal to "establish and maintain a model community or colony free from all forms of private monopoly." Lumber from Mobile was landed on the beach by lighter boat, but by the spring of 1895, the colonists had constructed a wharf. This 1897 view of early Fairhope was taken from Section Street. (Courtesy Harriet Swift.)

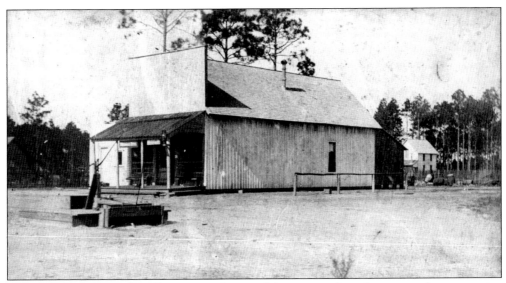

The Fairhopers' first order of business in their model town was the colony store, the cooperative Fairhope Mercantile, located at the corner of Fairhope Avenue and Section Street, which remains the town's main intersection. The store also served as the post office and central gathering place, especially due to the location of the town well in the foreground. (Courtesy Harriet Swift.)

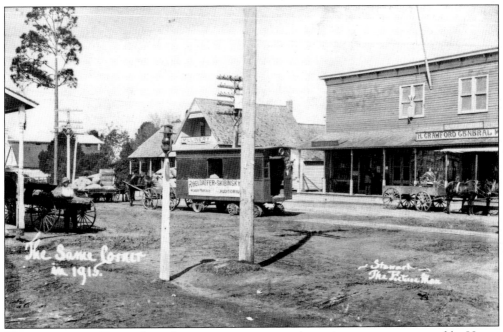

The same corner 15 years later shows improvements to the main store, now operated by Henry Crawford, and the development along Fairhope Avenue. The colony now boasted its own railroad leading to the wharf at the foot of the street. Engine power would later replace the mule-drawn rail cars in Fairhope, the first and biggest single-tax enclave in the United States. (Courtesy Reed Myers.)

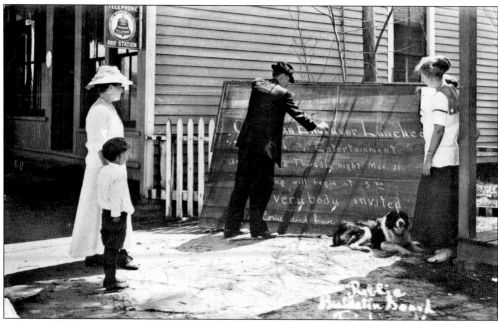

In the early days, everyone kept up with the latest events and announcements by keeping an eye on the local public bulletin board by the newspaper offices downtown. There was a well-attended club meeting or discussion group for civil discourse or heated debate, lecture, or luncheon nearly every day of the week in the town founded by inquiring intellectuals. (Courtesy Reed Myers)

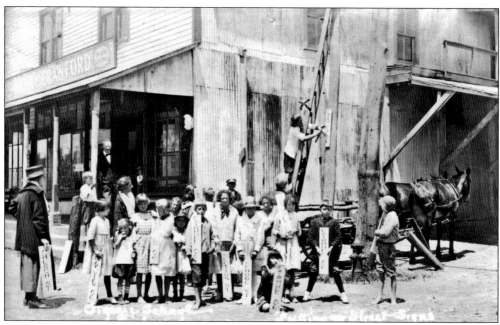

Students at Fairhope's famous Marietta Johnson School of Organic Education pitched in to make wooden street signs for the growing town's main thoroughfares. The private school drew many progressive families to the town. Helen Porter (Dyson), who later taught at the school, is hanging the hand-lettered Fairhope Avenue sign on the post. (Courtesy Helen Dyson.)

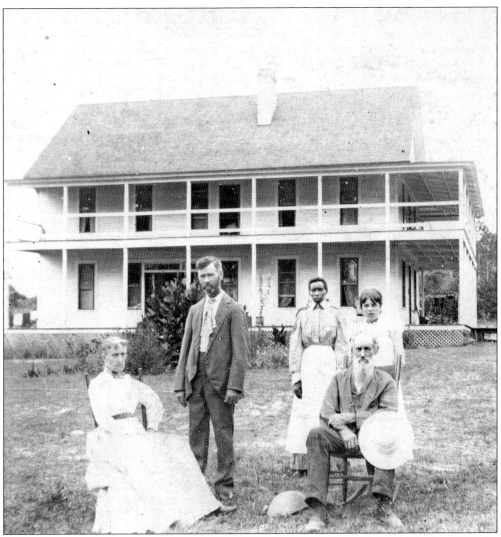

The Fairhope House on Magnolia Avenue was the town's first hotel, established in 1897 by single-taxers Delia Knowles Bancroft (left) and husband, George Bancroft (second from left). They met and married in Fairhope. Next to them from left to right are the hotel maid, Elia Lloyd; Delia's orphaned niece, Carrie Betts, who lived with them; and Delia's father, George Knowles, a surveyor and settler from Kansas. (Courtesy Wesley Stapleton.)

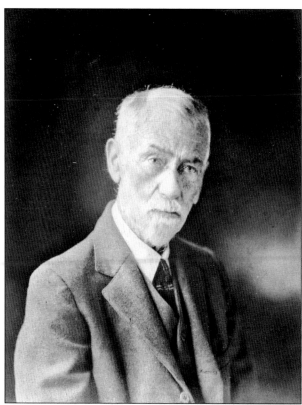

George M. Bancroft, who was simply called "The Man" by his family and friends, was an engineer who was active in the FSTC, serving as an early president and helping with its public improvements. Bancroft Street in the uptown commercial district was named in his honor. (Courtesy Wesley Stapleton.)

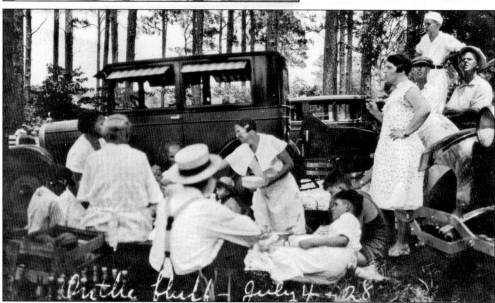

The Tuvesons, original colonists, enjoy a picnic on the bluff on July 4, 1928. The first Fairhope settlers came from Iowa, Ohio, Minnesota, Pennsylvania, and British Columbia. At first the so-called Yankees populated the Deep South settlement, but area residents began to move to Fairhope after 1899, when the single-taxers allowed others to join their venture. (Courtesy Flora Maye Simmons.)

Adolph Oscar Berglin and his new bride, Eva Bebolt, proudly pose on the day after their December 20, 1900, wedding. A Wisconsin native who became a leading businessman and mayor, Berglin established the Fairhope Ice and Creamery in 1909, one of the first creameries in Alabama. The couple built a large home at the corner of Fairhope Avenue and Church Street. (Courtesy Robert Berglin.)

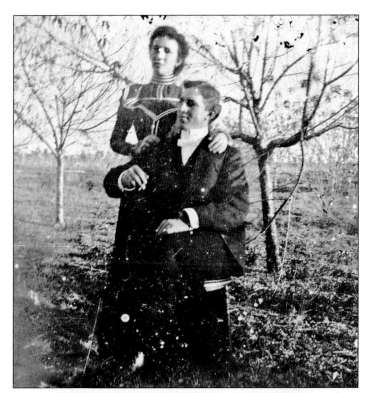

The family of Clayton Baldwin, who operated a general store, gathers on the front porch of their home, typical of the early modest Fairhope dwellings. The colony advertised that the "vulgar mansions of the predator rich" would not be found there. In the beginning, there was no private ownership of land in Fairhope, where residents had 99-year leases on their FSTC lots. (Courtesy Fairhope Historical Museum.)

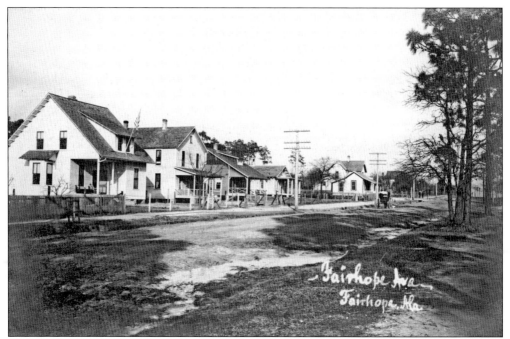

By 1913, comfortable Craftsman and Victorian cottages had been built along Fairhope Avenue, the main thoroughfare through what had once been a pine forest. The first three homes on the north side of the first residential block remain, while the fourth, the shotgun Mitchell Cottage, was razed for land speculation in 2004. (Courtesy Reed Myers.)

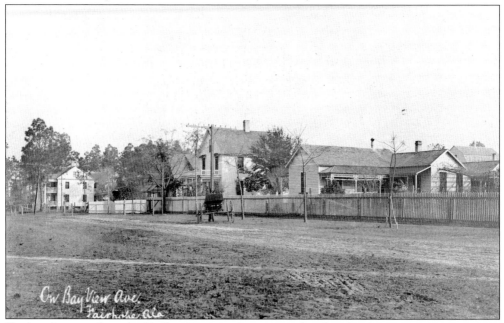

Homes also rose along the bluff on Bayview Avenue in what founder Gaston once wrote was "a city set upon a hill, shedding its beneficent light to all the world." By 1910, the colony owned over 4,000 acres in the town that was attracting new residents and vacationing visitors. (Courtesy Bill Payne.)

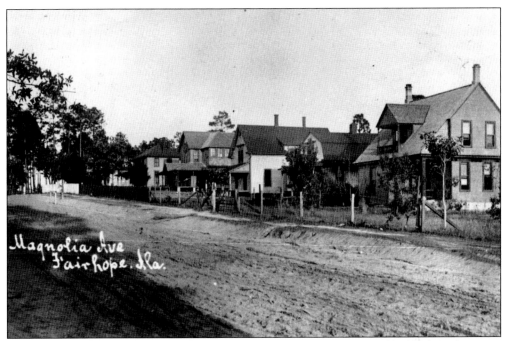

These homes, built on the south side of Magnolia Avenue in the 100 block when the street leading uptown from the bay was dirt, still stand. In the planned community of Fairhope, streets widened as they curved toward the bay to afford everyone a view of the water. Most of these homes were resort guest cottages. (Courtesy Flora Maye Simmons.)

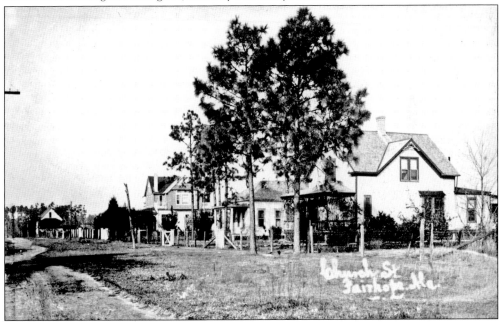

Church Street featured substantial residences, like the two-story house on the far right, which was built by Jonathan Beckner after he moved to Fairhope from Iowa in 1906. Listed on the National Register of Historic Places, it is today the Fairhope Inn and Restaurant at 69 South Church Street. (Courtesy Bill Payne.)

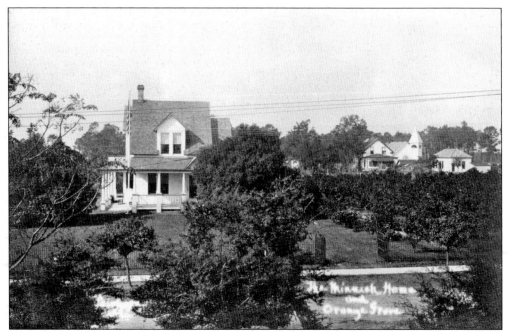

The home of merchant A. P. Minnich, built about 1912, stands at 78 South Section Street. It was once known for the large surrounding orange groves that Minnich planted. Orange and satsuma trees represented a cash crop for many Fairhope residents until a big freeze in 1924 killed the growing citrus industry. (Courtesy Reed Myers.)

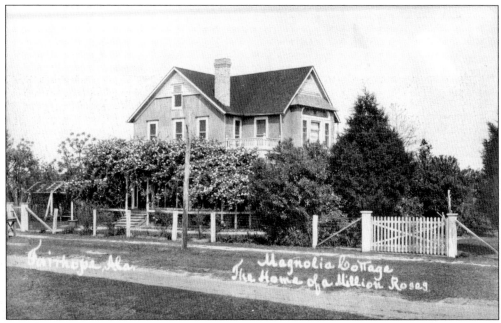

Fairhope's site was selected for its natural beauty. Called "Magnolia Cottage, The Home of a Million Roses" on a postcard by photographer Frank Stewart, this attractive home illustrates the fertility of the fragrant garden spot the colonists acquired at the edge of Baldwin County farmland, which remains a breadbasket for the surrounding area. (Courtesy Reed Myers.)

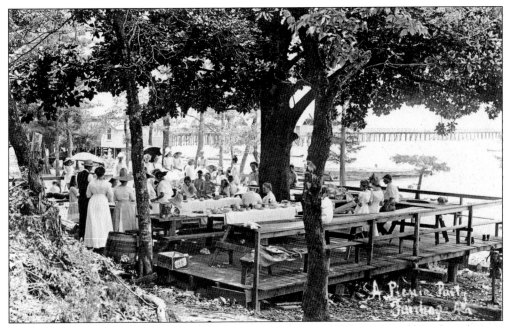

The Fairhope Village Improvement Club (VIC), organized in 1899, sponsored socials and oyster suppers with entertainment to raise funds for public projects. The VIC's first project was a picnic pavilion around the magnolia tree at the beachfront park. Fairhope's far-sighted founders had set aside nearly a mile of beach for public parkland. (Courtesy Claire Totten Gray.)

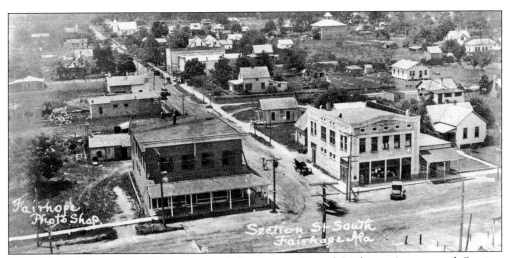

An early-20th-century bird's-eye view of the intersection of Fairhope Avenue and Section Street shows a prosperous town, with Wheeler's Store, where the Fairhope Esoteric Society held Sunday meetings upstairs, on the left corner. On the right corner is the landmark 1916 Fairhope Pharmacy, the state's oldest in its original location. (Courtesy Pinky Bass.)

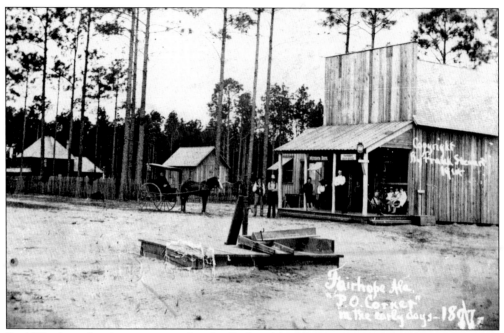

By 1912, the colony's cooperative Peoples Railroad had been constructed, with cars carrying goods and passengers from the wharf up Fairhope Avenue and back; however, the rails never ran the 14 miles east to the Louisville and Nashville Railroad at Robertsdale as planned. Soon the horse-and-buggy days would end in Fairhope. (Courtesy Bill Payne.)

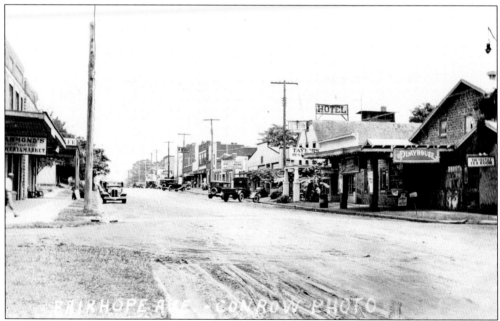

Called "a town with a purpose" by the *Fairhope Courier* newspaper, by the early 1920s, the village had many amenities of a larger town, including brick buildings and a theater. This view is looking east up Fairhope Avenue from Church Street. The heart of the experimental colony was becoming a thriving, prosperous urban center. (Courtesy Claire Totten Gray.)

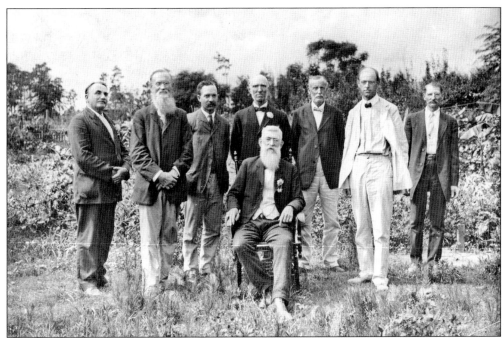

Fairhope incorporated in 1908 with 500 residents and elected its first city council. Seated is the mayor, Dr. Harris S. Greeno, who was not a member of the colony. The councilmen of the new municipality, from left to right, were Nathaniel Mershon, P. Y. Albright, Charles E. Nichols, Clement Coleman, W. Sweet, James Bellangee, and J. M. Pilcher. (Courtesy FSTC.)

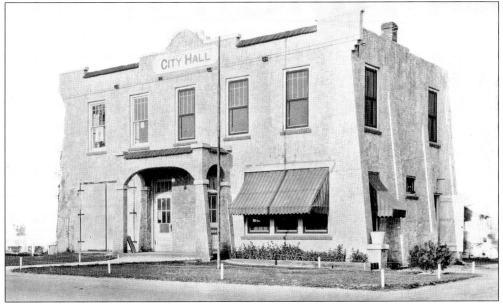

An imposing new city hall was built in the popular Spanish Mission Revival style in 1927 by local contractor Oswald Forster, a German native who came to Fairhope in 1912. The landmark at 24 North Section Street also served as the police station and city jail until 2001. This elegant building's original façade remains intact behind a metal false front. (Courtesy Azille Forster Anderson.)

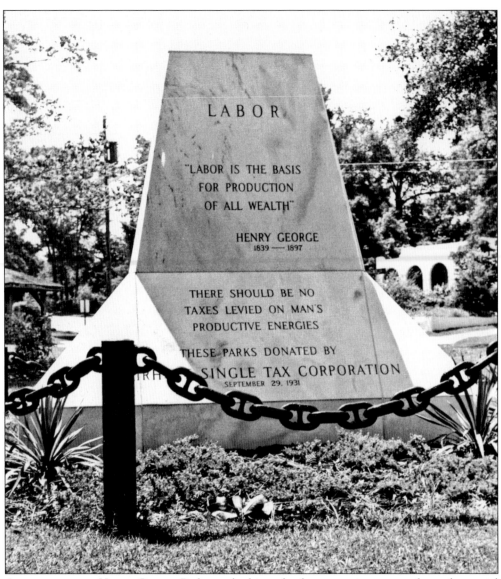

A monument at Henry George Park overlooking the bay contains quotes from the social economist whose single-tax philosophy was the guiding spirit behind the colony established on the principle of "cooperative individualism." In the early 1930s, the colony gave the beach and bluff parks and pier to the city for public use. (Courtesy FSTC.)

Three

DREAMERS AND REFORMERS

The "Single Tax" is so simple, so fundamental, and so easy to carry into effect
that I have no doubt that it will be about the last land reform the world will ever get.
People in this world are not often logical.

—Clarence Darrow

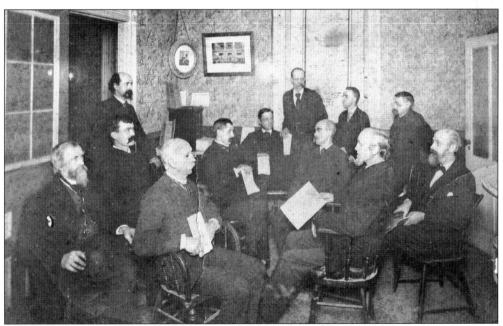

The Worcester Single Tax Club, meeting in Massachusetts in the 1890s, probably mirrored the Single Tax Club in Des Moines, Iowa, where the Fairhope experiment began. In 1890, the nation had over 130 single-tax clubs. Prescott A. Parker, seated at center to the left of the man standing, was an engineer and surveyor who settled near Fairhope, where he was an ardent reform proponent. (Courtesy Claude Arnold.)

Ernest Berry Gaston (1861–1938) was Fairhope's foremost founder. The idealistic Populist and Iowa journalist started the influential *Fairhope Courier* newspaper before the town he helped settle in 1894 even existed. A single-taxer influenced by George's philosophy, Gaston was the moving force behind the Fairhope Industrial Association, which became the Fairhope Single Tax Corporation. (Courtesy Rusty Godard.)

Dr. Clara E. Atkinson (1845–1932) was a longtime, well-loved physician in the town where Atkinson Lane is named for her. Pictured here as a young woman before leaving Des Moines, Iowa, she was single-taxer Gaston's half sister. Many independent women were drawn to Fairhope, where they had equal rights and a vote in colony matters. They also held office in the FSTC. (Courtesy Harriet Swift.)

Many adventuresome couples, like this unidentified pair who arrived on August 12, 1904, heartened by Fairhope's promise and reformist zeal, threw their fate to the winds and joined the colony. Though most were poor in pocket, they were rich in spirit. The colony provided newcomers with lots they could rent for 99 years to build homes and plant gardens. (Courtesy Harriet Swift.)

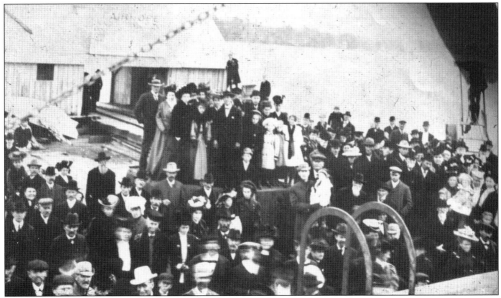

These Fairhopers seem to exhibit a sense of purpose even as they await a bay boat to attend the 1898 Mardi Gras celebration in Mobile, where the first Fat Tuesday observance in the New World took place. While Fairhope was filled with serious-minded reformers, the old French city across the bay let the good times and parades roll during the carnival season. (Courtesy FSTC.)

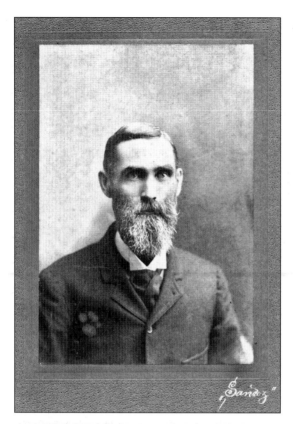

Alphonso Swift (1838–1915) another settler from Des Moines, arrived on Election Day, November 6, 1896. That was the day Fairhope supporter William Jennings Bryan was defeated for president. Swift owned most of the property in an affluent area that today calls itself the Bluff neighborhood. (Courtesy Harriet Swift.)

Paul Kingston Dealy (1848–1937) brought the Baha'i faith to the South when he moved from Chicago to Fairhope in 1898, attracted by the single-tax theory. Today the religion that believes in one God and one human race has groups in 120,000 localities, including Fairhope. The open-minded town also drew other metaphysical seekers, such as Scientologists and Theosophists. (Courtesy Jim Dealy.)

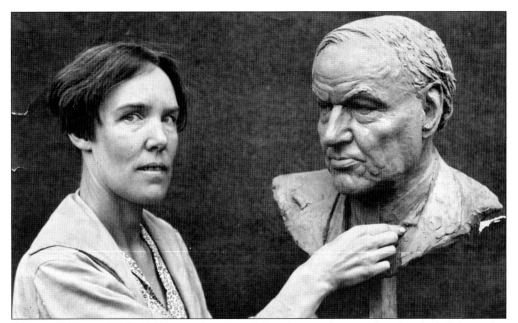

Clarence Darrow (1857–1938) was the nation's best-known lawyer when he spent his winters in Fairhope lecturing and writing in the 1920s and 1930s. The defender of the underdog had formed the Intercollegiate Socialist Society in Chicago in 1905 with Upton Sinclair, another famous resident. Kathleen Wheeler sculpted Darrow's likeness in Fairhope in 1927. (Courtesy Flora Maye Simmons.)

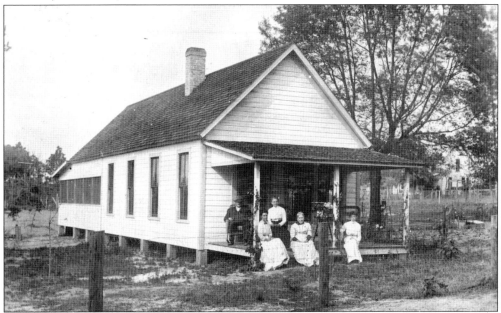

Coming to Fairhope to recuperate from the famed Scopes monkey trial, Darrow settled his younger sister Ethel in this tiny shotgun cottage (with unidentified family outside) at 83 Magnolia Avenue. The celebrated attorney thought his sister, who had trouble speaking, would be accepted in the small town that had so many eccentrics, and he often visited her here. (Courtesy Pinky Bass.)

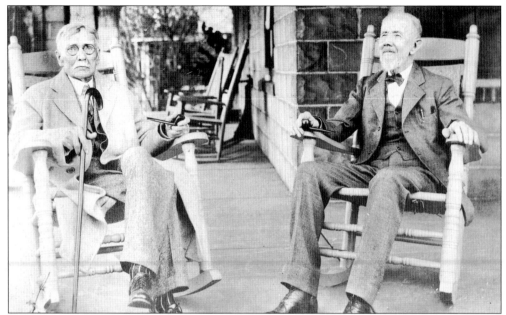

Capt. Jack Cross, right, visits with a guest at the Fairhope Hotel he built on Fairhope Avenue at Summit Street after settling in Fairhope in 1908. The English world traveler was called the "Sage of Fairhope." His great friend Darrow called Cross "a very pleasant companion that made me forget my illness and the Fundamentalists and the KKK that surround me." (Courtesy Fairhope Public Library.)

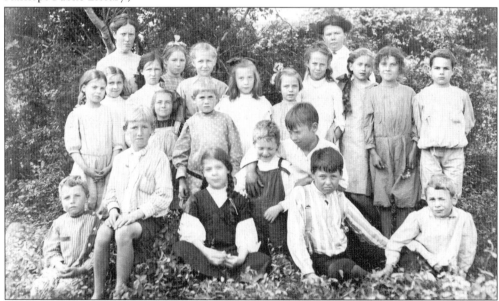

From the beginning, the colony supported education. Organic School teachers Lois Slosson, back left, and Olive Wooster, back right, pose with students c. 1908. From left to right are the following: (first row) Raymond Dyson, Ralph Brown, Grace Coutant, Kirby Wharton, and Rudolph Tuveson; (second row) Eleanor Coutant, Annie Stradling, and three unidentified students; (third row) two unidentified students, Matilda Lilly Bernhardt, Estelle Larson, Frances Kerr Goodrich, ? Coutant, Ester Gilmore, unidentified, Irene Rucker, and Clifford Ernest Johnson. (Courtesy Pinky Bass.)

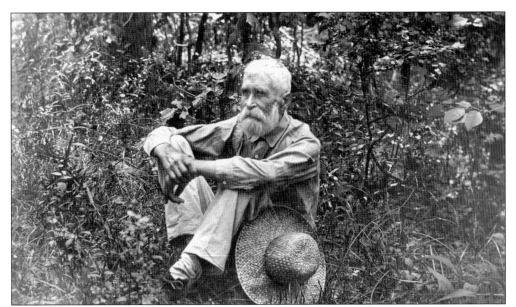

Henry James Stuart, also called the Hermit and the Old Weaver, moved near Fairhope to die in 1926, but he lived a long philosophical life in a masonry dome hut he built. The fascinating story of Stuart, who rarely wore shoes, inspired the 2005 novel *The Poet of Tolstoy Park* by Fairhope writer and bookman Sonny Brewer. (Courtesy Rusty Godard.)

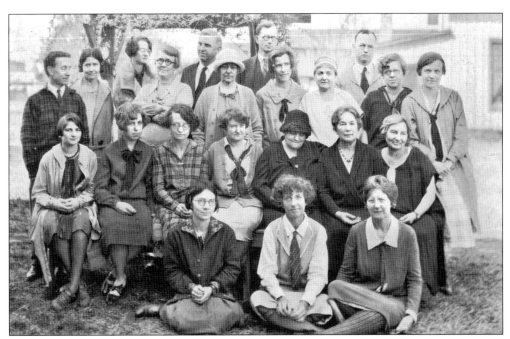

Progressive educator Marietta Johnson chose Fairhope to open her experimental School of Organic Education in 1907. The school became widely known, as Mrs. Johnson traveled across the United States and Europe lecturing on her educational philosophy and drawing many leaders in their fields of expertise to teach there. Mrs. Johnson is seated on the second row, second from right. (Courtesy Helen Dyson.)

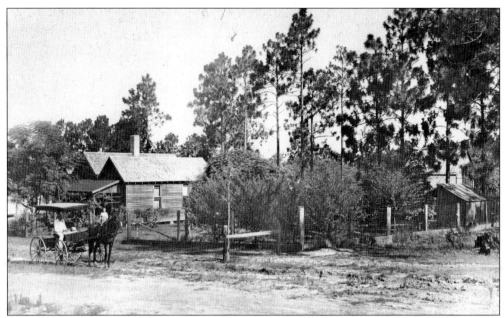

Many Quakers, like Asa Staples from West Branch, Iowa, settled in Fairhope, where the Friends established their own school and meetinghouse. Staples, the town's harness maker, sits in his buggy, with his wife on the porch of their pioneer home, which still stands at 159 Fels Avenue. He would sometimes read papers such as "Philosophy of the Beautiful" at the local Progressive League meetings. (Courtesy Cathy Donelson.)

The House of Totten, on Morphy Avenue, was purchased by Edward P. Totten, a judge and devoted single-taxer, shortly after he came to Fairhope from North Dakota with his young family in 1919. From left to right are Judge Totten and his children: Parker, who was killed in World War II, Claire, and Holly holding baby Joyce. (Courtesy Claire Totten Gray.)

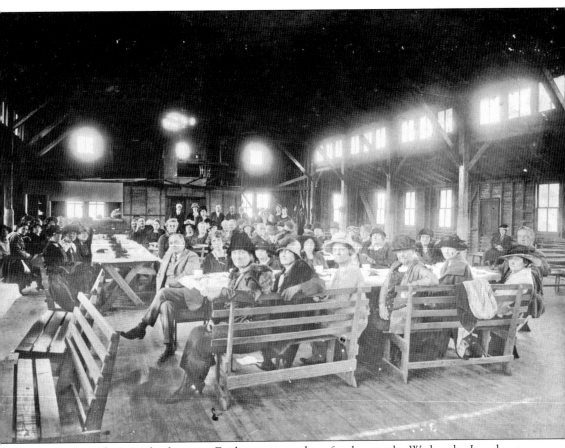

Inquiring minds wanted to know, so Fairhopers turned out for the popular Wednesday Luncheon held in Comings Hall on the Organic School campus. These mid-weekly luncheon gatherings featured discussions, noted speakers, and frequent lectures on topics ranging from philosophy to pure foods. This picture was taken in 1928, when the lunches were 50¢, but they had been a longtime community tradition. (Courtesy Helen Dyson.)

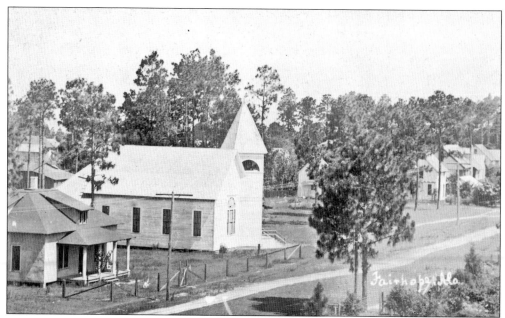

Spiritual matters were also at the heart of the colony's development. The Fairhope Christian Church, where many founding families worshipped, was built in 1901 on a lane that became Church Street. The site of the town's first church is now occupied by the Fairhope Kindergarten Center, which is housed in the first public high school building in the town, built in 1925. (Courtesy Pinky Bass.)

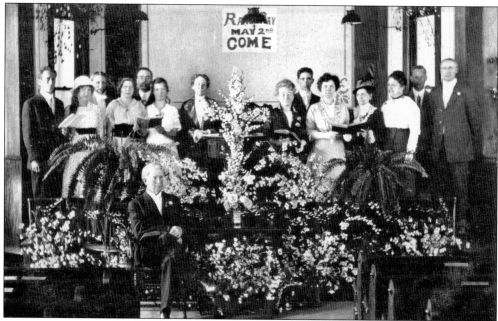

On Easter morning 1915, the Christian church was decorated with flowers and ferns and the choir posed. By 1908, Fairhope had a Baptist church on the next corner, and other denominations soon followed, as people of different creeds and backgrounds came to the cooperative community where all beliefs were respected. (Courtesy Reed Myers.)

Fairhope's first fireplace, the last relic of the original frame Gaston home on Fairhope Avenue, was commemorated by this gathering of the family in later years, when the dream of Fairhope had become a reality. Patriarch E. B. Gaston stands second from left of the old hearth, surrounded by his family members, children, in-laws, and grandchildren. (Courtesy FSTC.)

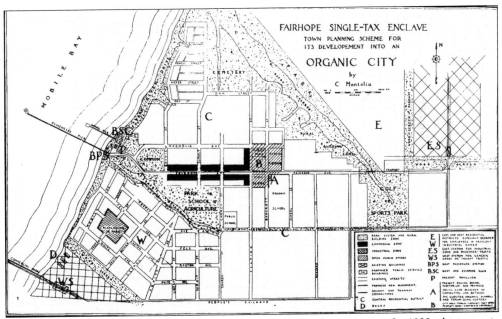

Fairhope was a planned community from the time it was only a concept. In 1922, this organic city plan developed by Cebria de Montoliu, an early proponent of the Utopian Garden City Movement, was supported by the FSTC, but it was never carried out. Montoliu, a Fairhope supporter from Barcelona, Spain, was the secretary of the Hispano-American Garden Cities and Town Planning Association.

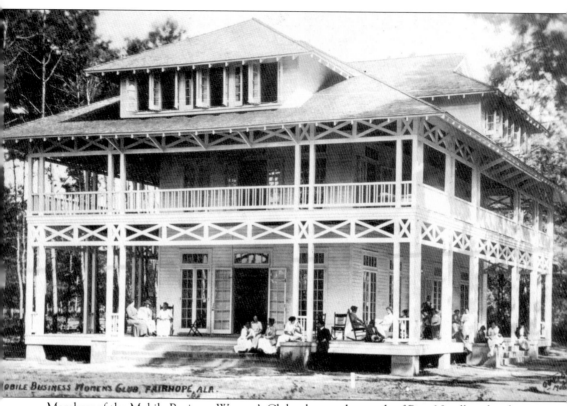

MOBILE BUSINESS WOMENS CLUB, FAIRHOPE, ALA.

Members of the Mobile Business Women's Club relax on the porch of Pine Needles, the elegant retreat they built overlooking the bay in the early 20th century in Fairhope, where women could vote and professional females were treated as equals with their male counterparts. The building at 700 South Mobile Street is today headquarters for American Legion Post 199. (Courtesy Reed Myers.)

Four

SPORTING RESORT

Moss Bayou is a lovely, easygoing resort town (though not as popular as it once was), located as it is where Magnolia River runs into the bay with worlds of giant live oaks and sandy roads that wind forever under the trailing Spanish moss.

—Robert Bell, *The Butterfly Tree*, 1950

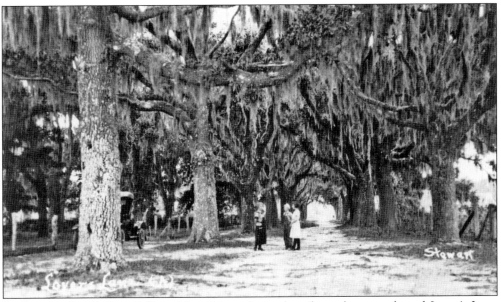

Fairhope author Robert Bell could well have been describing the moss-draped Lover's Lane south of town when he wrote about the mythical Moss Bayou in his classic novel *The Butterfly Tree*. In his novel that was really set in Fairhope, Bell wrote of its magic, beauty, and real-life characters—changing the names, of course. (Courtesy Reed Myers.)

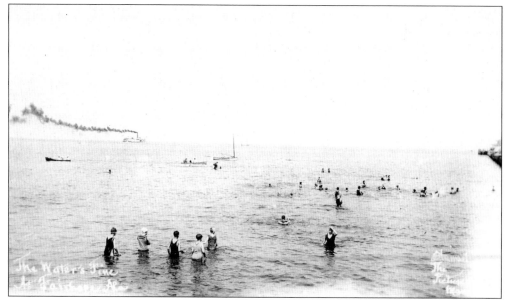

From its beginning, Fairhope was promoted as a seasonal resort and catered to visitors. As early as 1895, the *Fairhope Courier* newspaper reported that the town's location on the Eastern Shore was sought for "excellent bathing, boating and fishing and its health giving breezes from the salt water and piney woods." (Courtesy Rusty Godard.)

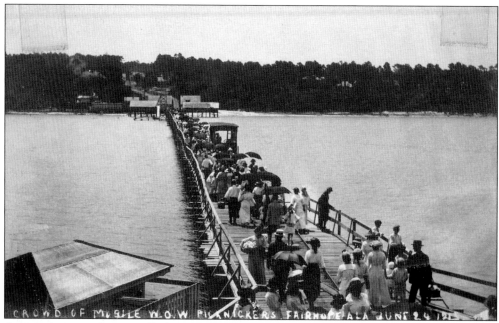

A typical scene of visitors flocking to the growing resort town shows members of Woodmen of the World arriving at the wharf in June 1914 from Mobile. Local leaders were promoting tourism, but few roads led into Fairhope at the time, so most of the transportation to the town was still by the bay steamers. (Courtesy Rusty Godard.)

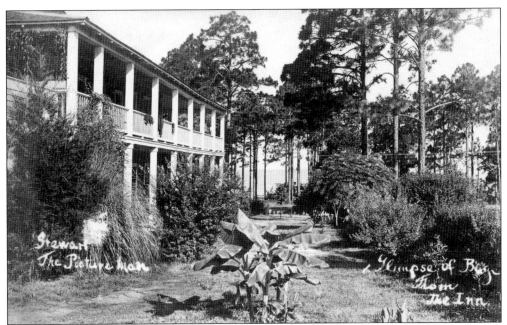

"It was a marvelous place that should have been preserved because of its unique personality among elegant hotels in the Deep South," said novelist Robert Bell of the Colonial Inn in a letter reproduced in the 2001 book *Meet Me at the Butterfly Tree* by Fairhope writer Mary Lois Timbes. The inn was once the town's grandest resort. (Courtesy Claire Gray.)

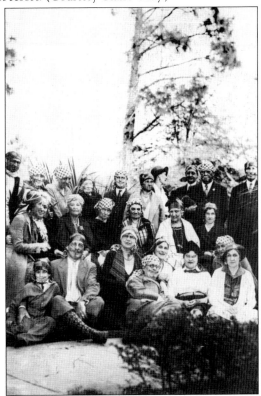

There was always a party going on somewhere in Fairhope, which had a population laced with fun-loving visitors and charming eccentrics. Here a group pretending to be pirates poses together to commemorate their costume party held at the Colonial Inn. (Courtesy Ken Niemeyer.)

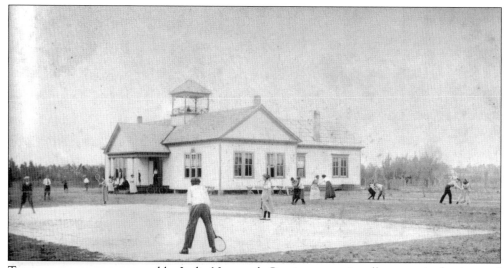

Team sports were encouraged by Lydia Newcomb Comings, a nationally recognized writer and lecturer on physical education who co-founded the Organic School in Fairhope. Here students do exercises in the schoolyard, while others play tennis on a clay court. Community tennis courts were also located on the bay bluff. (Courtesy Helen Dyson.)

An old-fashioned game of croquet is played about 1910 on the grounds of a family home called the Columns. Edwin Clayton and Cornelia Slosson moved to Fairhope from nearby Silverhill about 1908 and bought the neoclassical revival house on the northeast corner of Magnolia and Bayview Avenues. (Courtesy Pinky Bass.)

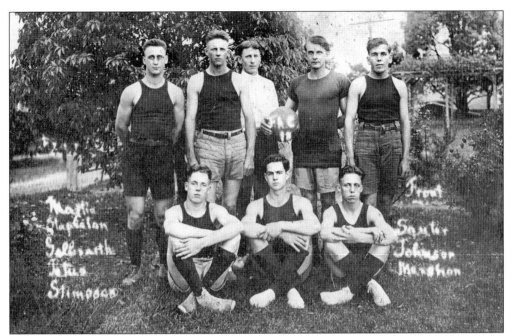

Basketball was still in its infancy in 1918—the indoor game was invented in 1891 to bridge the season between football and baseball—but Fairhope had a team. Members of the Fairhope Athletic Club's 1918 team were identified as, from left to right, (standing) Martin, Stapleton, Galbraith, Titus, and Stimpson; (seated) Souter, Johnson, and Mershon. (Courtesy Rusty Godard.)

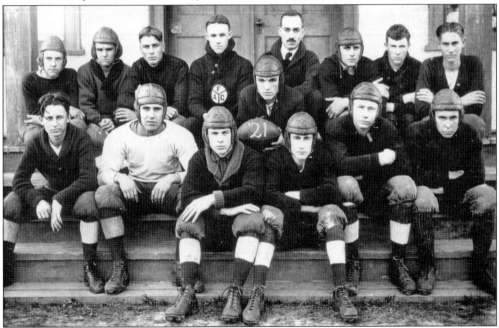

The Fairhope Athletic Club football team poses on the steps of the Bell Building at the Organic School, looking like the members are ready to take on all comers in 1921. That was the year the National Football League was organized. The sport was and still is popular in Fairhope. (Courtesy Helen Dyson.)

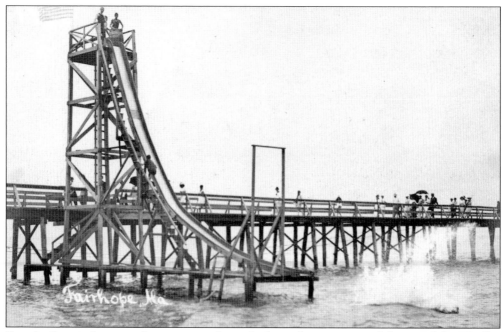

Daredevils wait their turn for a spine-tingling ride down the giant water slide named the Thriller at the Fairhope pier c. 1913. The slide was a leading attraction on Mobile Bay in its time, drawing tourists for thrills and possibly spills into the warm waters of the bay. (Courtesy Pinky Bass.)

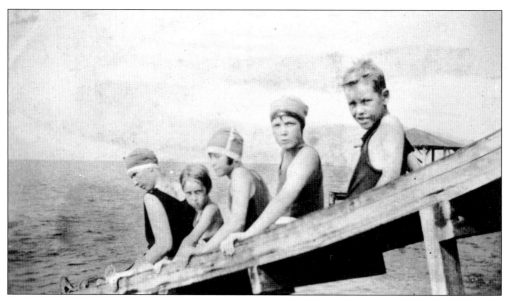

Ellen Slosson (far left), blind since childhood, braves the slide with, from left to right, her sister's children Ruth, Marion, Frances, and Edward. The children's mother, Lois Sundberg, was an early woman photographer who captured her family's activities and many other Fairhope scenes, providing the community with a valuable historic photographic record. (Courtesy Pinky Bass.)

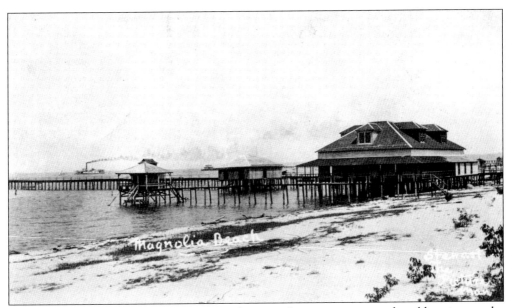

The Magnolia Beach Pavilion was a popular waterfront spot, as was the old casino at the Fairhope pier in the distance. The casino was a bathhouse and social hall and not a gambling establishment; however, many visitors and Fairhope residents back in the Roaring Twenties were not averse to a friendly wager over a game of cards. (Courtesy Reed Myers.)

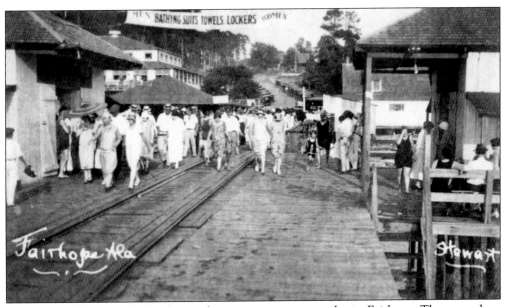

Tourists head back to the bay boats after enjoying a summer day in Fairhope. The town drew several thousand visitors on holidays, and the casino in the background was the town's biggest entertainment spot. Without large industry, a big part of Fairhope's economy was based on spending by visitors, as is the case today. (Courtesy Fairhope Historical Museum.)

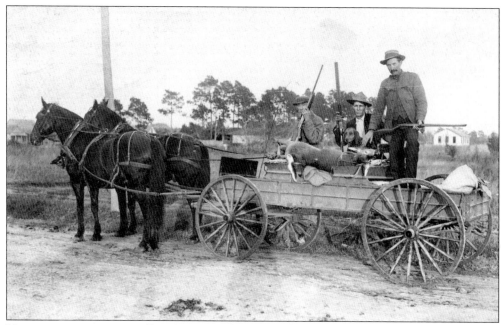

Hunting was a sport as well as a means of putting food on the table in the early days, when Fairhope was surrounded by woods. Curtis Rockwell (far left), who shot the deer, holds the wagon team that he brought from Iowa when he settled his Quaker family in Fairhope in 1915. (Courtesy Marietta Johnson Museum.)

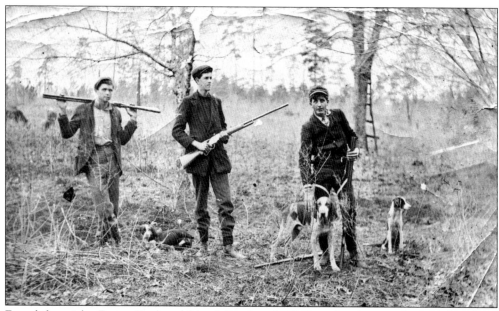

From left to right, Ernest Swift and friends Frank and Bill Davis head out to the fields for a hunt with their rifles and dogs in the early 20th century. A ladder to a tree-fork deer stand is in the background. Swift came to Fairhope as a boy in 1896 and became the longtime town policeman, nicknamed "Swifty." (Courtesy Harriet Swift.)

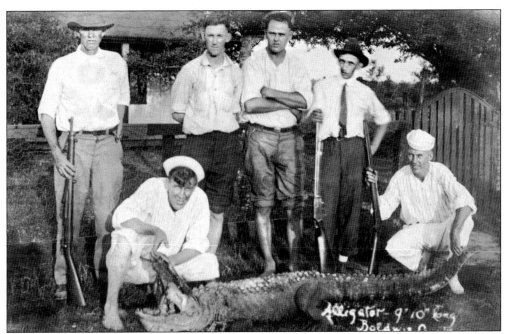

These hunters bagged an alligator. Standing from left to right are Sim Andrews, Ralph "Cotton" Brown, Rudolph "Reckless" Tuveson, and Harris "Quaker" Rockwell. Bill Schuler is at the head and Ed Wood at the tail. The Gulf and bay were a fishing paradise, drawing sportsmen from over the country, and fish camps still abound in the area. (Courtesy Flora Maye Simmons.)

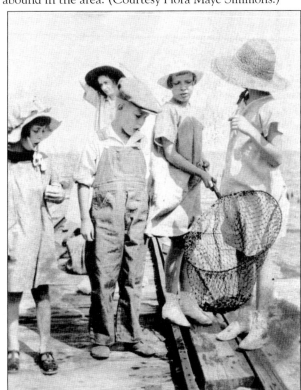

In the foreground from left to right, the Sundberg siblings, Ruth, Edwin, Frances, and Marion, catch a mess of blue crabs at the Fairhope pier, still a prime spot for crabbing, fishing, and experiencing glorious sunny days. Behind the children, family friend Mrs. McLaughlin pauses to adjust her sun hat. (Courtesy Pinky Bass.)

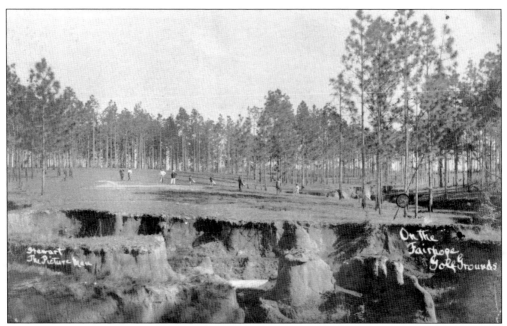

The Fairhope Golf, Gun, and Country Club opened in 1916 with a nine-hole course designed by famed golf architect Walter Fovargue of Chicago. The golf course on Fairhope Avenue east of Marshall's Gully was subdivided into residential lots in the 1950s, but its clubhouse still stands at 651 Johnson Avenue. (Courtesy Harriet Swift.)

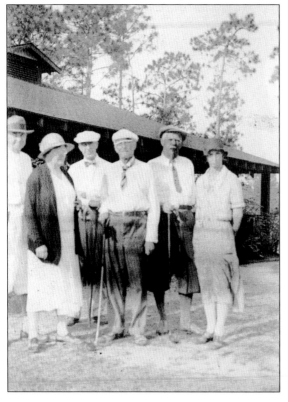

Mr. and Mrs. George Yonk Skinner (the couple at far left) join a fashionable golfing party in front of the clubhouse, now a residence. The Craftsman-style clubhouse, which also hosted parties and dances, was built on FSTC land to attract winter visitors from the North. It was dedicated at a New Year's Night celebration in 1923. (Courtesy Ken Niemeyer.)

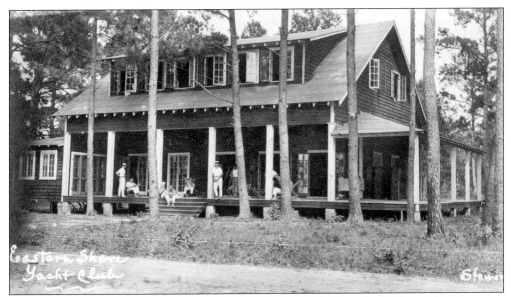

Sailors lounge on the porch of the Eastern Shore Yacht Club. It was built after a 1916 hurricane destroyed the Mobile Yacht Club, the oldest on the Gulf Coast. In the 1940s, the building on South Mobile Street became the La Corona dance club, open to teenagers until 9 p.m. and adults only the rest of the evening. (Courtesy Flora Maye Simmons.)

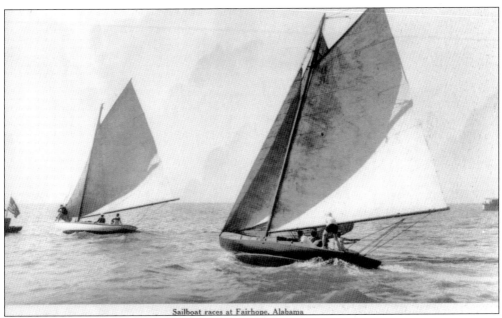

These graceful fish boats racing on the bay's premier sailing waters originated in 1918. The new fish class inspired the formation of the five-state Gulf Yachting Association (GYA). Fairhope's first yacht club was an original member of the GYA, which began the famed Lipton Cup Regatta. The present Fairhope Yacht Club on Bayou Volanta was founded in 1942. (Courtesy Cathy Donelson.)

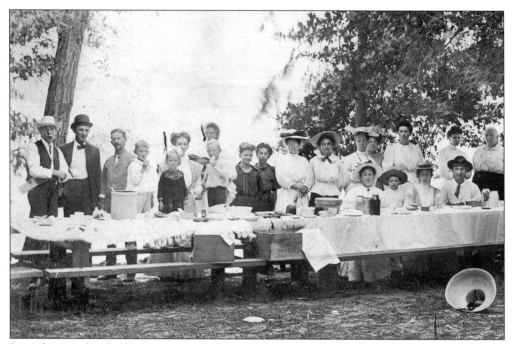

Picnicking under the fragrant pines in the gentle breezes on the bay bluff has always been part of the laid-back lifestyle in Fairhope, where outdoor community gatherings are a tradition. Here a group gathers at a long table decked with linens, china, and, no doubt, homemade delicacies and Fairhope's famous seafood. (Courtesy Robert Berglin.)

Fairhope's balmy weather and slow pace engrossed others in more sedate outdoor activities such as reading on the peaceful bluff promenade. Naturalist William Bartram passed through the area in the late 18th century, and his blissful descriptions of its magnificent magnolia groves and scenery in his book *Travels* influenced romantic poet Samuel Coleridge's imagery in *Kubla Khan*.

Five

AN ART COLONY

My cabin was on a strip of beach and beyond the beach the mouth of a river came down into the bay. Banking the two shores of the river were wharfs where boats came in and tied up to receive cargo and from where boats went out to the ports of the world.

—Sherwood Anderson, *Paris Notebook*, 1921

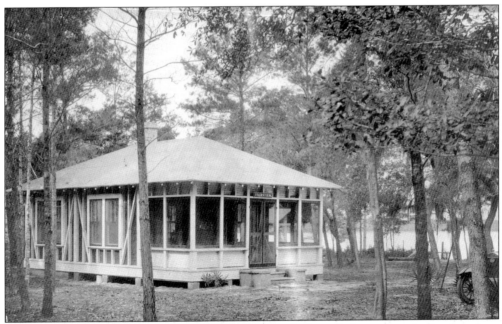

Sherwood Anderson, acclaimed for *Winesburg, Ohio*, which made him a force in the American short story, retreated to Fairhope in 1920. He wrote in a cabin in the woods, perhaps someplace like this typical rustic waterfront cottage near town. His wife, Tennessee Mitchell, used local models to create clay faces to illustrate his story collection *The Triumph of the Egg*. (Courtesy Rusty Godard.)

Marie Howland was a Socialist writer and free-love advocate who came to Fairhope in 1899 from an intentional community at Topolobampo, Mexico, shown here. Author of the famous labor novel *The Familistre*, she became associate editor of the *Fairhope Courier* and helped establish the town's library with her extensive rare-book collection. (Courtesy Topolobampo Collections, Special Collections, California State University, Fresno.)

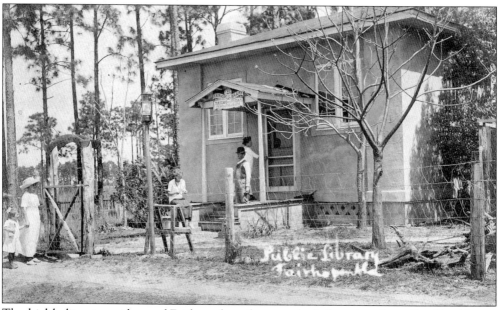

The highly literate residents of Fairhope heavily patronized the original small public library. The building at 10 North Summit Street served from 1906 to 1983 and is now a part of the headquarters of the University of South Alabama Baldwin County campus. When Mrs. Howland died in 1921, a service was held in the library she founded. (Courtesy Cathy Donelson.)

Frank Stewart (1855–1942) was "The Picture Man," who preserved a priceless record of Fairhope in his photographs documenting the town and its people from the beginning. Stewart, perhaps the area's most important artist and visual historian, is shown here washing prints in a clear stream. No photographic book about Fairhope would be complete without his superb and valuable legacy of silvered prints. (Courtesy Pinky Bass.)

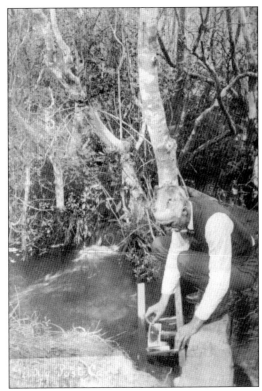

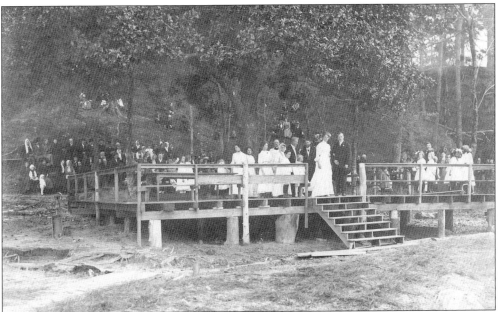

Upton Sinclair possibly attended friend Anna Pope Randolph's wedding on the bay front. America's most famous writer when he spent part of 1909 and 1910 in Fairhope, he wrote his novel *Love's Pilgrimage* in a tent on the bay bluff. Celebrated for his muckraking book *The Jungle*, Sinclair believed in single-tax communal living and wrote about Fairhope in his essay "Enclaves of Economic Rent." (Courtesy Pinky Bass.)

Olive "Piney" Wood Gaston was a well-respected Fairhope musician and published poet. She played the piano for decades at weddings, churches, and Organic School folk dances. Arriving from McGregor, Iowa, in 1911 with her widowed mother, she later married the first man she saw when she stepped off the bay boat: James E. Gaston. (Courtesy Barry Gaston.)

Lydia J. Newcomb Comings was another of the town's remarkable women. The noted physical education teacher, writer, and lecturer had studied and traveled throughout Europe. The pioneer who helped found the Organic School also served as president of the FSTC. She also was prominent in club and library work and was a historian who founded the Baldwin County Historical Society. (Courtesy Helen Dyson.)

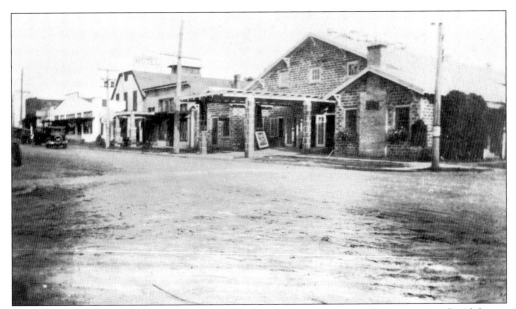

The Magnet Theater, built in 1924, was the longest-running movie house in South Alabama when it closed in the mid-1970s. Built of local Clay City tile by attorney and entrepreneur Edward P. Totten, it also featured a tearoom called the Tea Tile. The landmark at the corner of Fairhope Avenue and Church Street has been converted into shops, but the original projection booth remains upstairs. (Courtesy Claire Totten Gray.)

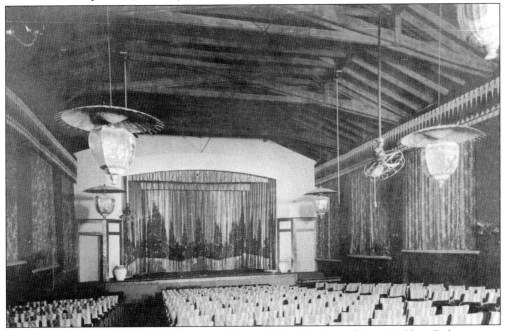

The sumptuous interior of the Magnet, designed by Mobile architect J. Platt Roberts, was remarkable for a small South Alabama town like Fairhope, where fewer than 1,000 souls lived. The cinema also drew crowds from the countryside. The theater's builder, Judge Edward P. Totten, was fascinated about the future of moving pictures and had first started showing movies at the Organic School. (Courtesy Claire Totten Gray.)

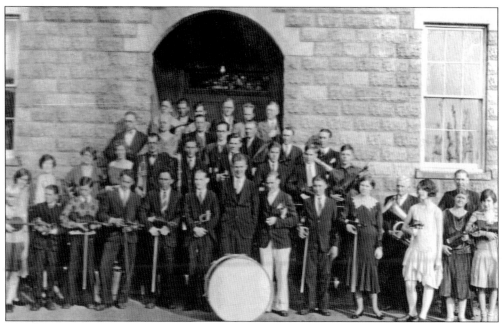

The colony filled with artists, writers, and musicians even has its own song, titled "Fairhope," with lyrics by early councilman J. M. Pilcher and music by his wife, Hazel, a graduate of the Boston Musical Conservatory. Here the Baldwin County Orchestra, made up of mostly Fairhope musicians, poses with their instruments in the 1920s in front of the old public school building. (Courtesy FSTC.)

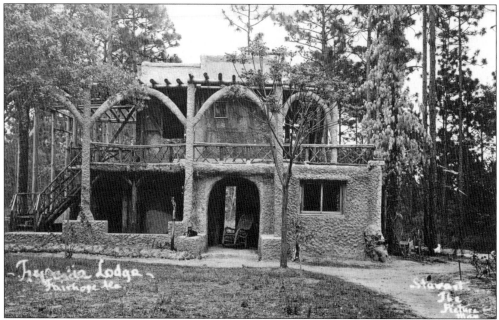

Architecture also was art in the distinctive settlement that featured many one-of-a-kind structures. Emma Schramm, a self-sufficient teacher, started building her home out of trees and mud and cement about 1915. Trycadia Lodge, now demolished, illustrates the individualist character and grit of many who were drawn to Fairhope. (Courtesy Claire Totten Gray.)

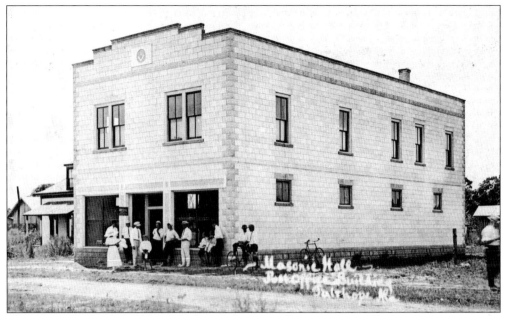

The Greeno Masonic Lodge, with downstairs post office, was one of Fairhope's first two-story masonry buildings. The structure at 66 South Section Street, built in 1911 by English-born local builder Marmaduke Dyson, featured a molded masonry block made of indigenous materials such as beach sand. The dimpled Dyson concrete would become a distinctive early building block of Fairhope. (Courtesy Pinky Bass.)

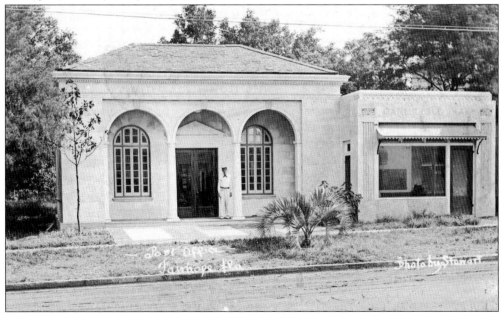

Fairhope's next post office, designed and built by prominent contractor Dyson and his sons in 1932, is listed on the National Register as the county's finest Italian Renaissance Revival architecture. It now houses the historic *Fairhope Courier* newspaper at 325 Fairhope Avenue. To the right, the Dyson-built Bloxom Building is another registered landmark important for its art-deco style. (Courtesy Palmer Hamilton.)

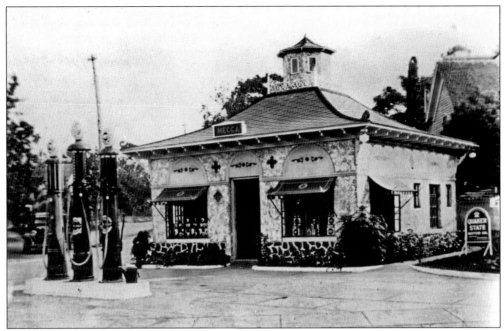

The Mecca, a whimsical service station built by Gulf Oil dealer and contractor Oswalt Forster about 1936, featured a pergola-style roof topped by a lighthouse cupola. The old gas station at 218 Fairhope Avenue is one of several in town that have been recycled into boutique shops catering to the tourist trade. (Courtesy Azille Forster Anderson.)

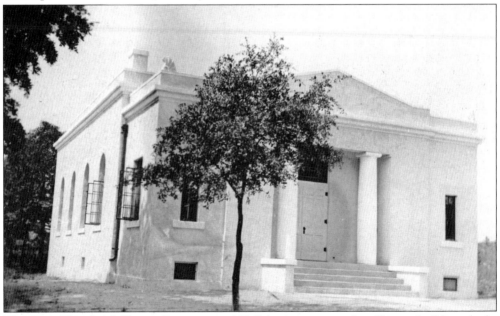

The First Church of Christ, Scientist, at 301 Fels Avenue, another Forster building, looks like a miniature Greek temple with its distinctive Tuscan columns. Built in the late 1930s, the Christian Scientist church graces a residential street named for Fairhope benefactor Joseph Fels of Philadelphia, a wealthy single-taxer and philanthropist who made his fortune with Fels Naphtha Soap. (Courtesy Azille Forster Anderson.)

Robert Bell captured Fairhope's enchantment in his coming-of-age novel *The Butterfly Tree*, published in 1959. In a search of the mystical butterfly tree, he portrays a dream world called Moss Bayou but bases characters on real people. "Miss Claverly" was Winifred Duncan, another Fairhope writer, dancer, and eccentric naturalist who wrote *The Private Life of the Protozoa*. (Courtesy Bill Bell.)

Bell called Gretchen Riggs his guru. An important part of Fairhope's artistic community, she had studied abroad and also at the American Academy of Dramatic Art. As a musician, Broadway stage actress, teacher, mystic, and self-described psychic, she was a mentor to youngsters and a moving force behind many plays at the local Theatre 98. (Courtesy Stephen Riggs.)

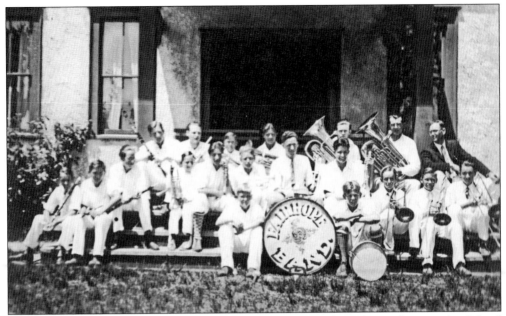

Music and art were an important part of life in Fairhope, where the students at the School of Organic Education had their own band. The school's original Bell Building at 10 South School Street now houses the Marietta Johnson Museum. The Fairhope Historical Museum is in another wing. The town also features the Eastern Shore Art Center and numerous private galleries. (Courtesy Marietta Johnson Museum.)

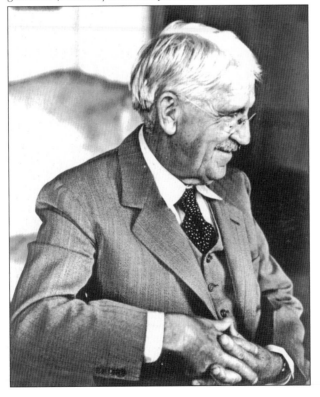

Dr. John Dewey was one of the nation's many influential thinkers and writers who made pilgrimages to Fairhope. Some who settled in the art colony included noted children's book author and illustrator Anna Braune, philosopher Baker Brownell, and prolific authors Frances Gaither and Eleanor Risley. (Courtesy University of Chicago, Center for Dewey Studies.)

Six

EXTRAORDINARY
EDUCATION

Mrs. Johnson is trying an experiment under conditions which hold in public schools, and she believes that her methods are feasible for any public school system. She charges practically no tuition, and any child is welcome. She calls her methods of education "organic" because they follow the natural growth of the pupil.

—John Dewey, *Schools of To-Morrow*, 1914

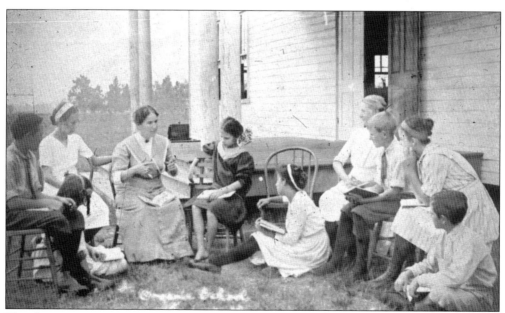

The frontispiece of John Dewey's influential book *Schools of To-Morrow* features Marietta Johnson teaching outside at her famous School of Organic Education. The scene is also the model for the bronze sculpture grouping on the Fairhope bluff. Dewey, the past century's foremost educator and philosopher, centered his groundbreaking book on education around Mrs. Johnson's school after visiting in 1913.

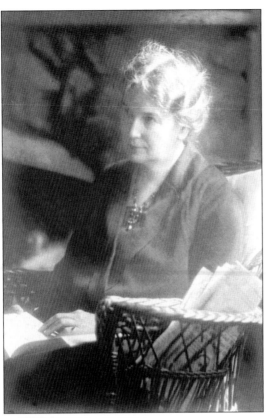

Marietta Johnson (1864–1938), known around the world as a progressive educator, opened her experimental school in the colony in 1907, drawing intellectuals from all over the country to teach there. A founder of the Progressive Education Association who lectured across America and Europe, she authored two books, *Youth in a World of Men* and *Thirty Years with an Idea*. (Courtesy Marietta Johnson Museum.)

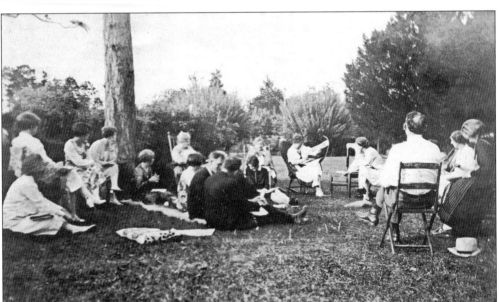

Teachers' training classes were often conducted outdoors on the Fairhope campus. Dewey wrote, "To this spot during the past few years students and experts have made pilgrimages, and the influence of Mrs. Johnson's model has led to the starting of similar schools in different parts of the United States." (Courtesy Marietta Johnson Museum.)

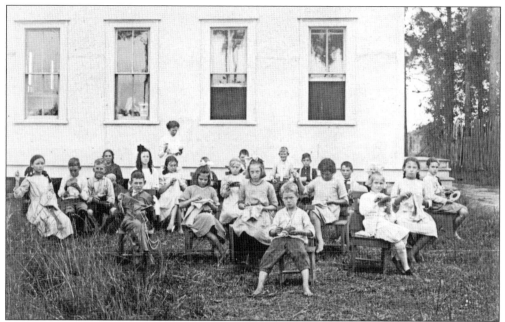

Children do handwork in a class outside *c.* 1910. "Nature has not adapted the young animal to the narrow desk, the crowded curriculum, the silent absorption of complicated facts," Dewey wrote about Mrs. Johnson's practice of holding classes out of doors. Early-20th-century progressives such as Upton Sinclair and poet Vachel Lindsay sent their children to the Organic School. (Courtesy Pinky Bass.)

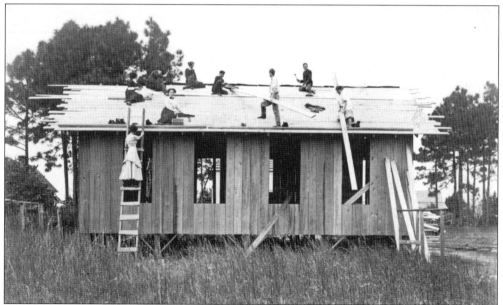

The Organic School began in the Bell Building, a former public school building, and the FSTC provided a 10-acre campus in 1909. Here students join teachers in roofing the new Domestic Science building, where children helped prepare hot 10¢ lunches for students. Clarence Darrow also lectured at the school on subjects such as Tolstoy to help raise funds. (Courtesy Helen Dyson.)

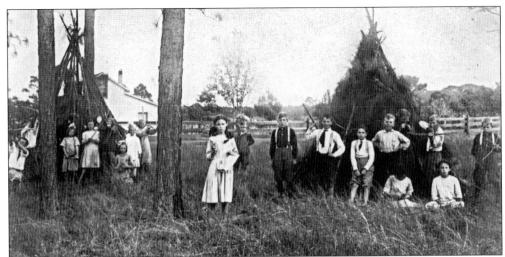

Students learned by doing at the Organic School and studied American Indian history and culture by creating teepee villages. Mrs. Johnson believed that children should learn to work together and have healthy activity. She discouraged teaching them to read at an early age. Life classes at the school were made up of general age groupings, with the youngest ones in First Life. (Courtesy Claire Gray.)

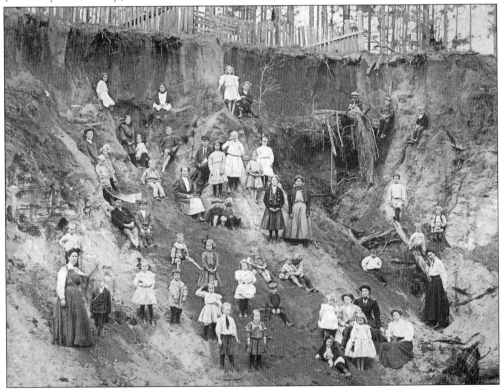

The gullies near the school were an exciting place to explore and also served as outdoor textbooks for nature study and geology lessons illustrating soil and rock formation. Archery classes also were held in the deep ravines. In 1908, a school group gathers in a gully for lessons with teachers and Mrs. Johnson, who is at the far left. (Courtesy Robert Berglin.)

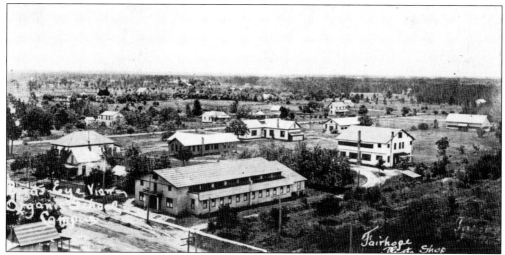

This overview of campus shows the growth of the Organic School in the 1920s, at its peak. In the late 1980s, the school sold its campus, which now holds Faulkner State Community College. The original Bell Building has been restored and is a museum. The school, entering its second century, continues to operate on a smaller scale in a new facility in Fairhope. (Courtesy Reed Myers.)

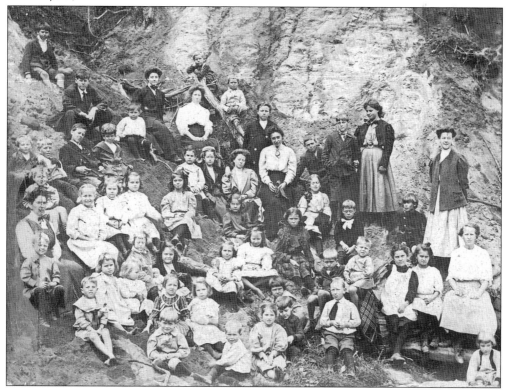

The gullies running through Fairhope down to Mobile Bay served as walkways through the town for many years. Here another group of Organic School students pauses during a field trip to pose in one of the gullies, where the walls were often used as chalkboards. Classes were held outside whenever possible, weather permitting. (Courtesy Robert Berglin.)

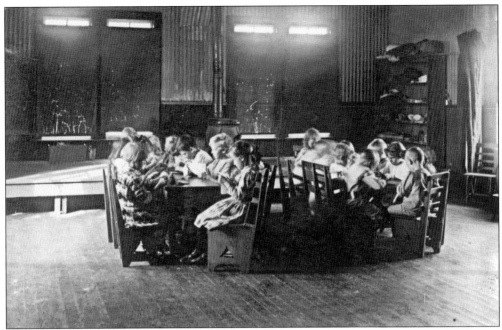

Classes also were held inside at the Organic School. In the early days, the school held no examinations and no homework was assigned, so children would have more time for play. The philosophy at the nationally known experimental school was that no child should be allowed to fail. (Courtesy Pinky Bass.)

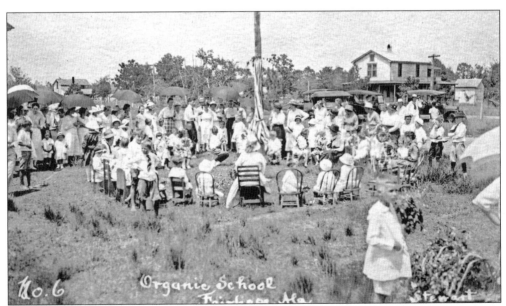

May Day, with the maypole dance, was one of the many festivals celebrated at the progressive school, where play was emphasized as an important part of learning. Non-competitive and creative games were encouraged. "The greatest minds," Mrs. Johnson wrote, "are those able to use the play spirit in work." (Courtesy Helen Dyson.)

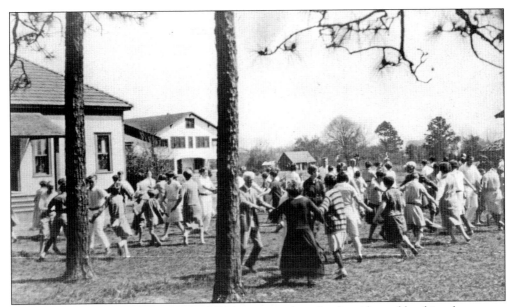

Everyone was welcome to join in the folk dancing at the school, evidenced by this robust scene in front of the Bell Building. Dance was one of the required subjects for both boys and girls at the Organic School, and many community dances were held on the campus in the heart of town over the years. (Courtesy Marietta Johnson Museum.)

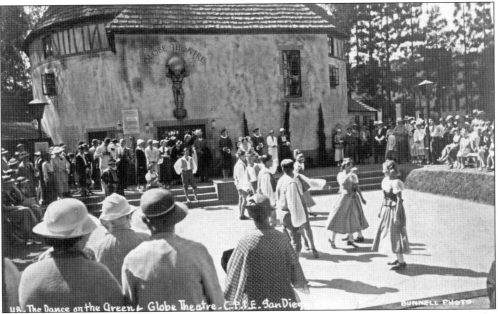

Students demonstrate folk dance on the green at the Old Globe Theater in San Diego in the 1930s. Organic School dancers performed across the country, from California to Chicago to Washington, D.C. Mrs. Johnson, who believed folk dancing was adapted to the schoolroom, wrote, "It is objective and purposeful, it is highly social and very beautiful." (Courtesy Claire Gray.)

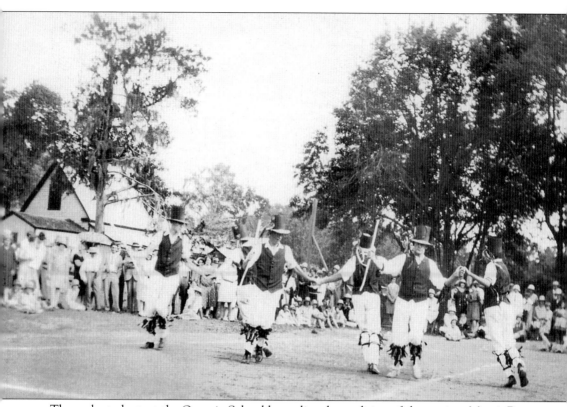

The male students at the Organic School kept alive the tradition of the ancient Morris Dance, an old ritual English dance, along with the sword dance and other folk dances. Charles Rabold, a protégé of the leading English folklorist, Cecil Sharp, left Yale University to teach at the school, turning the Fairhope dance program into one of the best in the country. (Courtesy Marietta Johnson Museum.)

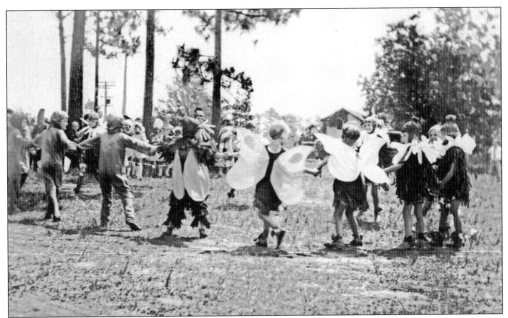

Even the little ones, dressed here in fairy costumes, learned the dances. Storytelling and dramatization often took the place of bookwork at the school. Students made their own costumes and acted out myths and stories. Often they would perform an entire literary tale without direction from a teacher. (Courtesy Marietta Johnson Museum.)

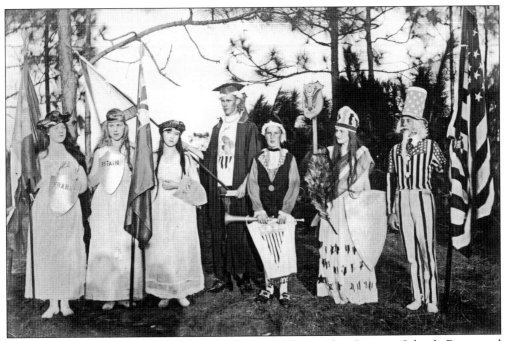

"Uncle Sam," at right, is part of a patriotic program at the Organic School. Renowned anthropologist Margaret Mead's younger sisters attended the Fairhope school. Mead later wrote that Elizabeth graduated, but her sister Priscilla insisted "I am not organic" and opted for a more traditional education back East. (Courtesy Marietta Johnson Museum.)

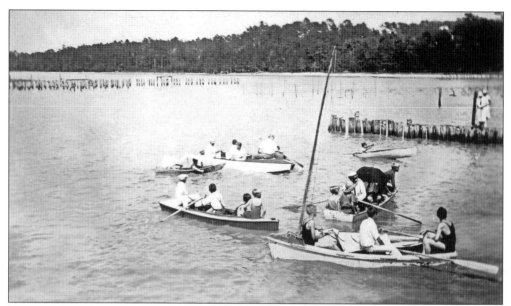

Boats made at the school were launched in the bay in the early 1920s. Both boys and girls took shop at the school, which drew master craftsmen as teachers. Wharton Esherick, who became a nationally known woodcutter and artist called the "Dean of the American Craftsmen," taught students math in 1919 by making woodworking measurements. (Courtesy Marietta Johnson Museum.)

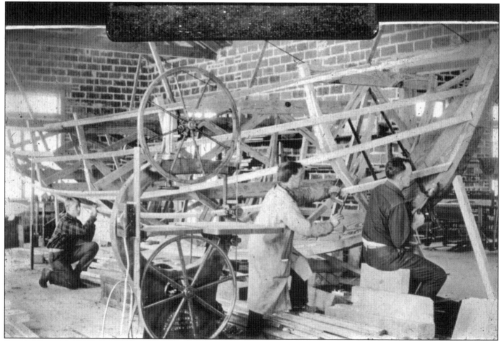

Teachers work on the *Osprey* sailboat in the Manual Arts Building at the Organic School as part of shop class. The wooden boat sailed the waters of the Gulf for several decades. Students also made tables and chairs for the school classrooms in the shop building. (Courtesy Marietta Johnson Museum.)

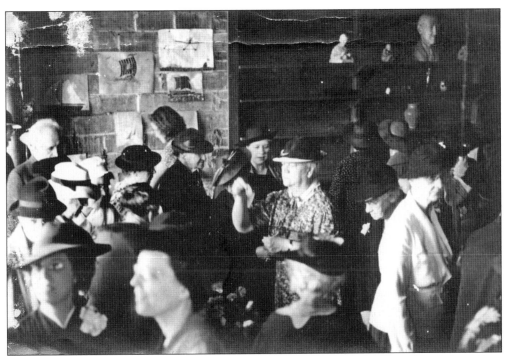

The annual Silver Tea was a tradition at the school, where students raised funds by selling their exquisite hand-made silver jewelry and artwork. Master silversmiths, weavers, potters, and sculptors on the school faculty taught the crafts. This Silver Tea was held at the school in the 1940s. (Courtesy Marietta Johnson Museum.)

The Friends School, left, was started in 1915 for children of Quaker families who came to Fairhope. The Meeting House was built next door for worship in 1919, but before that, the meetings were held in the schoolhouse. Remodeled into business use, the school still stands by the Friends Meeting House east of town on Fairhope Avenue. (Courtesy Cecil Rockwell.)

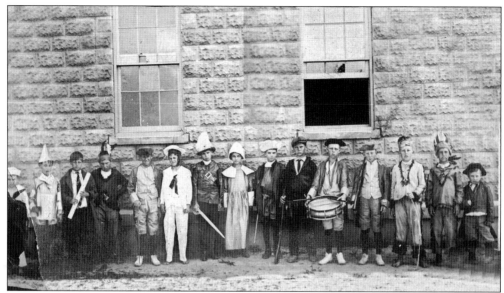

Pageants also were part of the educational program at Fairhope's public school, where students celebrated Thanksgiving with this program in 1914. The town had a public educational system from its earliest days. The first school was in a small frame building uptown in Fairhope, where schooling was mandatory, according to the colony's original constitution. (Courtesy Robert Berglin.)

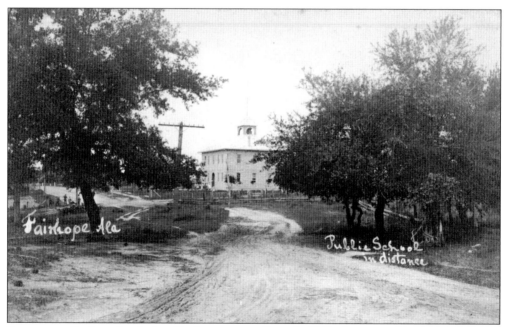

Everyone walked to school when Fairhope was a village. In 1909, this new public school was built at the corner of Church and Morphy. The large building, demolished in 1979, housed all grades until 1925, when a new high school was built across the street. The Fairhoper's Community Park, built by volunteers, is on the site of the former school. (Courtesy Reed Myers.)

Seven

ON THE MOVE

Rowing is a sport for dreamers. As long as you put in the work, you can own the dream.
When the work stops, the dream disappears.

—Haywood Broun

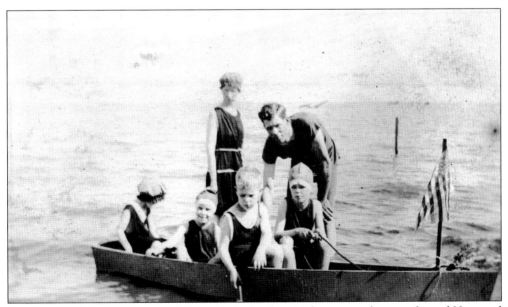

Sportswriter Haywood Broun, who attended school in Fairhope, was the son of noted Haywood Hale Broun, member of the famed Algonquin Circle. He may have been remembering idyllic days rowing on the bay, like these youngsters. Here contractor Reuben E. Sundberg plays with his four children in a boat flying an American flag. (Courtesy Pinky Bass.)

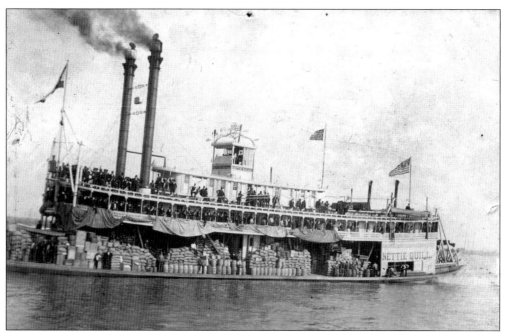

The *Nettie Quill*, loaded with goods and passengers, made trips from Mobile up the Alabama River and back and brought many Fairhope settlers downriver. Fairhope author Eleanor de la Vergne Risley, who wrote about pioneer life in Alabama, described the riverboat in *The Road to Wildcat*, published in 1930. (Courtesy Rusty Godard.)

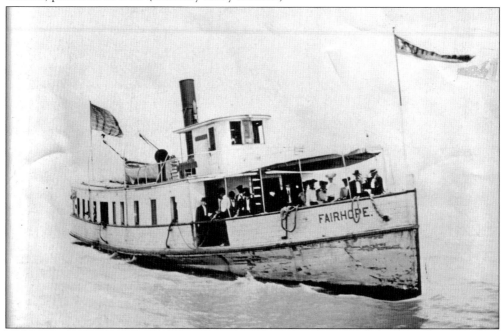

The first order of business in the fledgling settlement was a wharf and steamer to bring supplies over from the port of Mobile and move residents back and forth across the bay, so the colony built its own boat, *Fairhope*, in 1900. Fares on the bay boat with the distinctive red smokestack were 25¢. (Courtesy FSTC.)

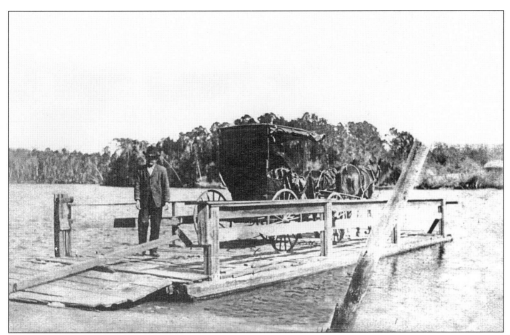

Herman Mannich, shown here in 1915, operated the Mannich Ferry across Fish River at Marlow. As a boy, the pioneer witnessed Adm. David G. Farragut's fleet in the river after the Civil War battle of Mobile Bay in 1864. Mannich Ferry was on an early trail from Pensacola, one of the few overland routes to Fairhope, as most transportation was by water. (Courtesy Bobby Mannich.)

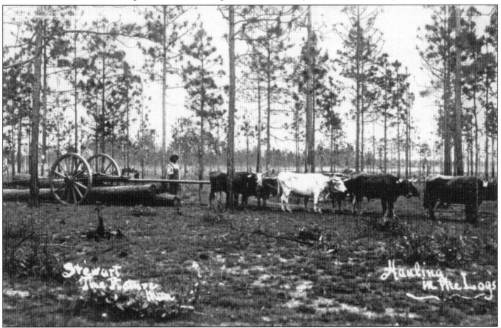

One of the first industrial ventures was a sawmill to provide lumber for building. Oxen hauled heavy pine logs from the woods and also pulled the milled timbers and boards. Townspeople claimed they could recognize an ox driver by the rolling gait he developed from walking beside his team—even if he was dressed for church. (Courtesy Helen Dyson.)

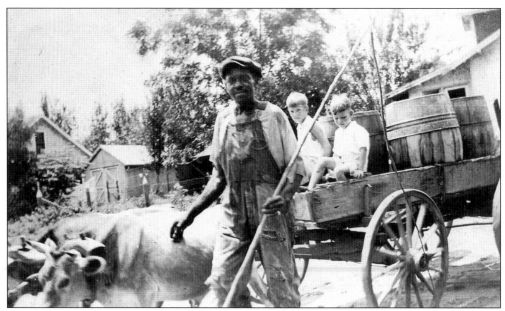

Cows also pulled their loads in Fairhope. Here some children ride on a cow wagon along Church Street. In the background is the home of the Browns, who owned a sawmill and brickyard where Thomas Hospital is today. The house is now a coffee shop at 302 Delamare Avenue. (Courtesy Robert Berglin.)

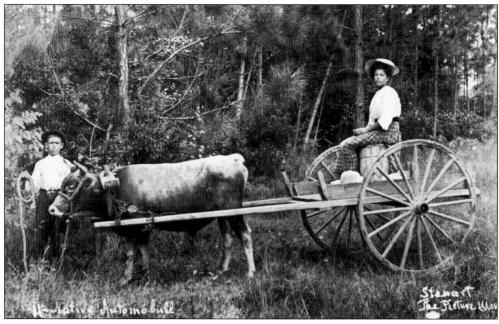

"Native Automobull" is the tongue-in-cheek title early-20th-century photographer Frank Stewart gave this picture he took of a woman and boy with a steer-drawn cart. Wagons and carts were the main mode of transportation through the piney-wood lanes around Fairhope for those who did not have automobiles. (Courtesy Reed Myers.)

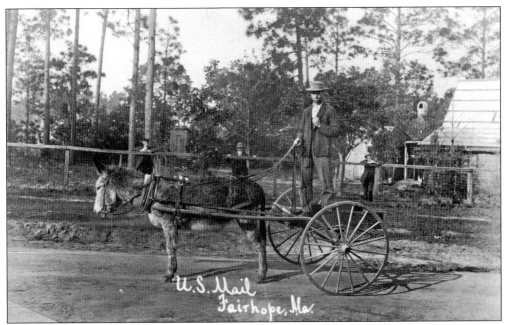

The postal carrier pauses to pose for the camera while driving the small U.S. Mail buggy through Fairhope. Onlookers seem to await delivery of mail, which came over the bay daily from Mobile on the mail packet *Lucille*. Letters were often addressed with the name of a residence, because Fairhopers were fond of naming their cottages. (Courtesy Marietta Johnson Museum.)

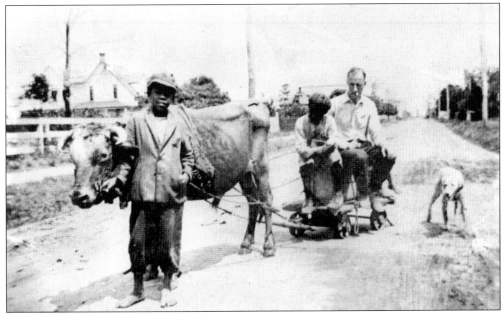

Alf Kyle, who was the director of the reptile section of the Bronx Zoo in New York, takes a break from snake hunting by hitching a playful ride down Section Street. In Fairhope to visit relatives, Kyle also spent time collecting specimens for the zoo, and there's no doubt he found many. (Courtesy Claire Gray.)

The Berglin and McBroom parents watch from the porch of the Pinequat Shop as their children go for a ride down Fairhope Avenue in 1914 in a double-seated miniature wagon pulled by a large sheep. The Berglins' home, which no longer stands, was moved from Fairhope Avenue around the corner to Church Street to make way for construction of the Magnet Theater. (Courtesy Robert Berglin.)

Children used to catch rides on the horse-drawn milk wagon as it made its rounds of the town. Soon horse and mule-powered vehicles would be replaced, as new motorized modes of transportation made their way to Fairhope, which was still a small island-like enclave. (Courtesy Harriet Swift.)

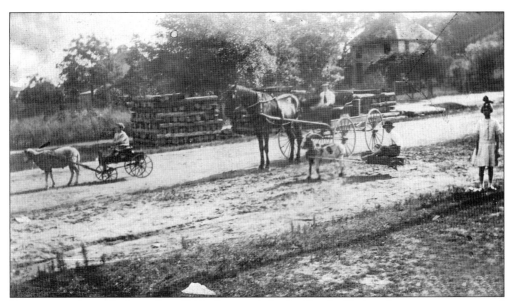

Buggies ran alongside the rails in 1912 when track for the Peoples Railroad, a company sponsored by the colony, began to be laid along Fairhope Avenue to the wharf. Here ties are stacked for the train line that was planned to connect the town to the nation's railway system, but it never grew beyond local service. (Courtesy Robert Berglin.)

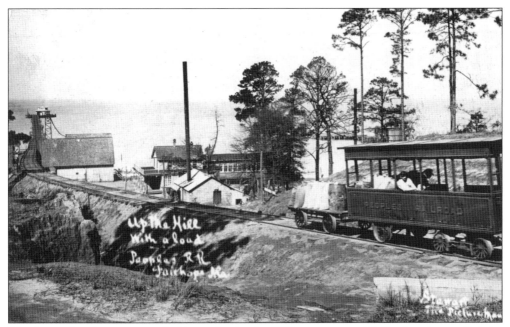

The first railroad cars were pulled by mules, but by 1920, motorcars with Ford engines pulled the loads up to 15,000 pounds to help with the shipment of outgoing crates of locally grown oranges and other goods. Here passengers ride uptown on the rails that were the small town's economic lifeline. (Courtesy Reed Myers.)

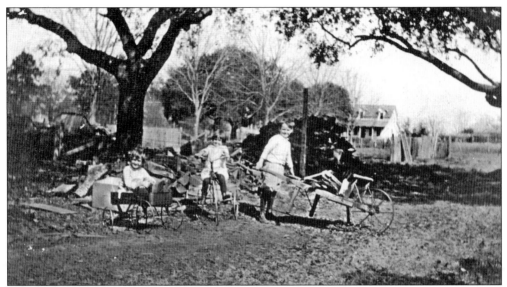

From left to right, the Swift children, Susan, Jane, and Philip, show off different types of kiddy vehicles, including a tiny wagon and early tricycle. They also rode a small donkey about town in the days before parents had to be concerned about traffic and children playing in the streets in Fairhope. (Courtesy Harriet Swift.)

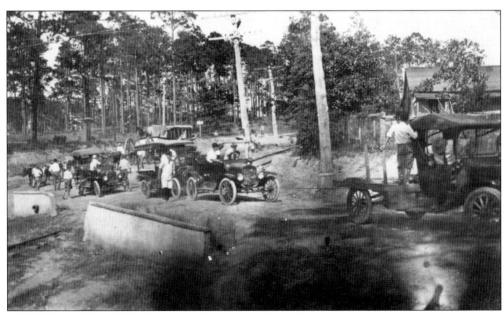

Motorized vehicles became available after the turn of the century, beginning with the popularity of Henry Ford's affordable automobiles. Here a procession of cars turns the steep curve off Fairhope Avenue onto Mobile Street, towing a newly constructed boat to the launch. Knoll Park is in the background. (Courtesy Harriet Swift.)

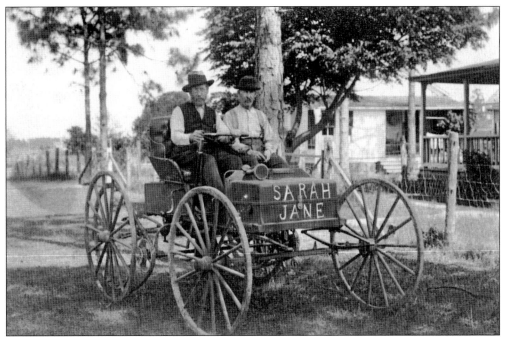

Edwin Clayton Slosson, left, and brother Gene ride in *Sarah Jane* in 1911. Slosson, a New York native, owned a sawmill and machine shop. Once they were not able to stop the car, so they circled the yard and finally lassoed a tree. The Holsman auto, which was guided by a lever, previously belonged to Dr. C. L. Mershon. (Courtesy Pinky Bass.)

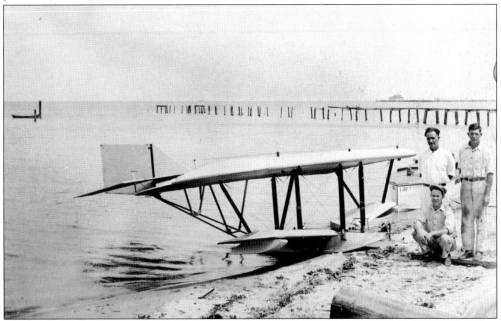

Flight also came to Fairhope. Walter Forster built this one-passenger glider out of Honduran mahogany and pulled it over the water with a speedboat he named the *Azille* after his daughter. The Forster brothers gathered by the plane are Herbert (left), Fred (right), and Walter (kneeling). (Courtesy Azille Forster Anderson.)

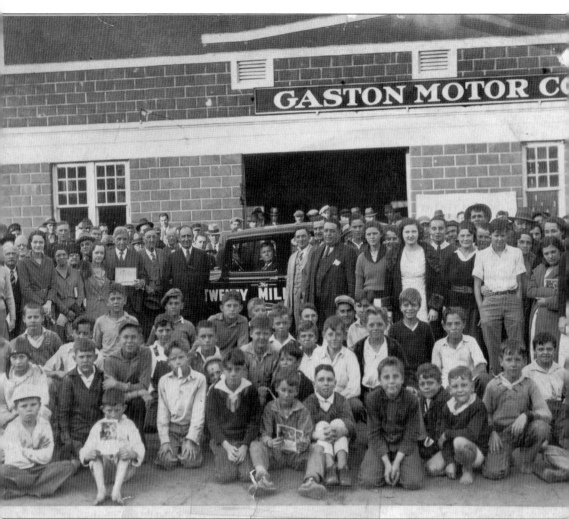

The town turned out for the visit of the Twenty Millionth Ford. This 1931 Model A touring the country for publicity was once displayed in the Henry Ford Museum. James Gaston, who had started with an auto livery business in 1914, later opened an early Ford dealership in this c. 1920 building, still standing at 403 Fairhope Avenue. (Courtesy Helen Porter Dyson.)

Eight

BUSINESS IS BOOMING

Let us show that from under the mild skies of Alabama shall come forth another colony,
a little economic child of social justice that shall lead the misdirected,
but terribly destructive forces of modern society to lie down together.

—E. B. Gaston

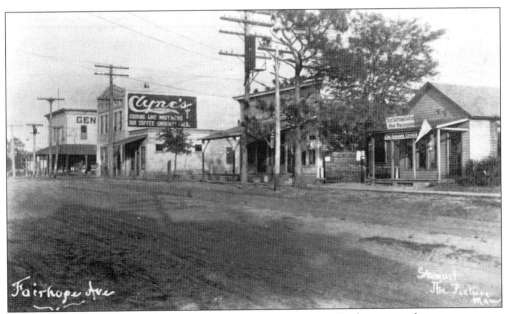

Called a poor man's effort by newspaper publisher E. B. Gaston, Fairhope grew from a concept to a community. At the far right is the original office of the *Fairhope Courier*. First published in Des Moines, Iowa, in the fall of 1894, before settlers left for Alabama, it reported "Fairhope's Model Community will be a reality within a few weeks." (Courtesy Harriet Swift.)

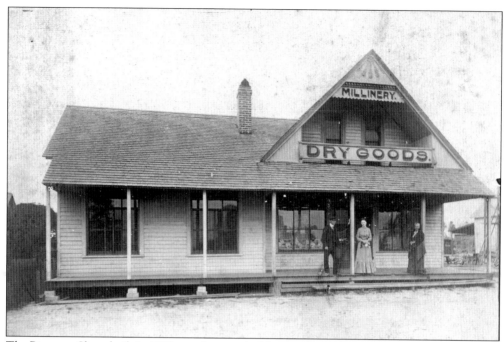

The Pinequat Shop, built in 1899, was the town's oldest operating business until 1959, when it was demolished to make way for a new bank building at 387 Fairhope Avenue. The shop specialized in local souvenirs like chinaberry beads, candied figs, and kumquat jellies, in addition to fancy ladies' hats. (Courtesy Rusty Godard.)

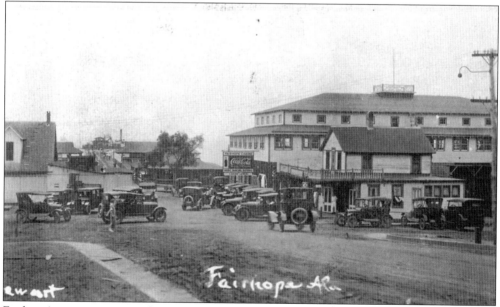

Fairhope's economy centered on tourism and catering to visitors. The casino, which dominated the bay beach by the pier, was the local bathhouse and gathering place for swimming and entertainment. The summer season was a busy one, with many groups making day trips from Mobile on the bay steamers. (Courtesy Reed Myers.)

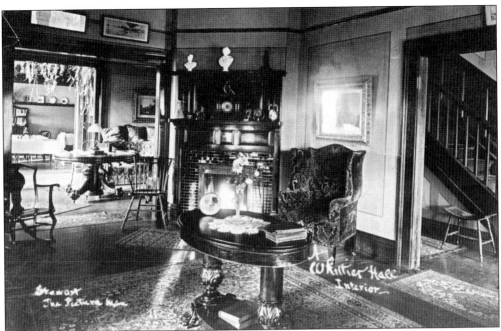

Other places such as Whittier Hall, which opened in 1911, catered only to winter visitors. The showplace hotel at 201 Magnolia Avenue, now a residence, was operated by Mr. and Mrs. A. N. Whittier. They had been in the florist business in Niagara Falls and planted semi-tropical plants on the hotel grounds. (Courtesy Reed Myers.)

The Colonial Inn stood on Mobile Street overlooking the bay. Here an interesting group is gathered on the grounds of the hotel that attracted well-heeled sophisticates from the East and cities like Chicago. Many Northerners came to Fairhope to spend the winter months, enjoying the mild climate away from the ice and snow. (Courtesy Ken Niemeyer.)

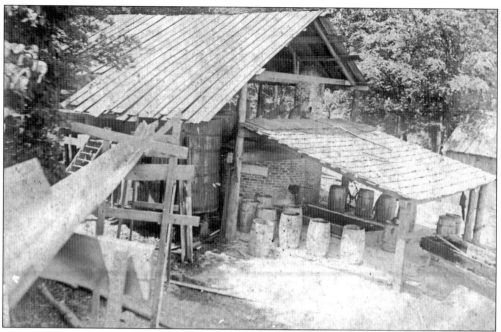

This early turpentine still on the bay was part of an important local industry that provided a livelihood for many men in the community. They gathered the sap from the plentiful pine trees in the area for the turpentine-making operations. The industry had existed long before Fairhope was founded. (Courtesy Harriet Swift.)

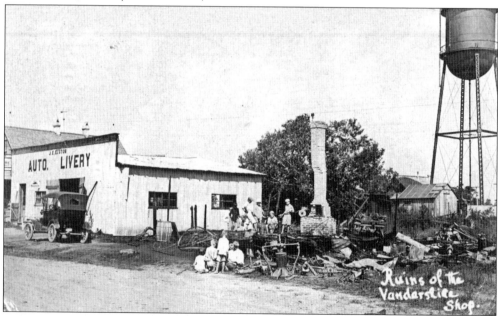

Every town had a blacksmith shop, but King Vanderslice's shop went up in flames in 1916. Townspeople fought to keep the fire from spreading to the garage next door, where gasoline drums were stored. Curious children inspect the charred remains from the blaze that destroyed Vanderslice's automobile as well as the motorcycle of his helper, Rudolph Tuveson. (Courtesy Reed Myers.)

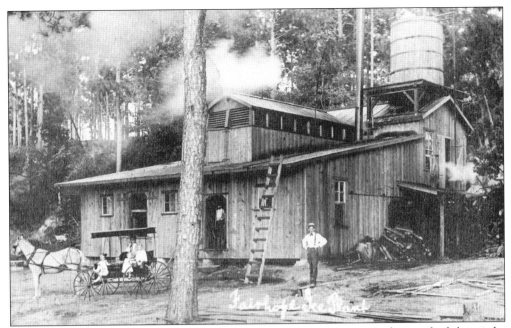

A. O. Berglin's ice plant on the bay was one of the early industries in Fairhope, which boasted a population of nearly 500 by 1904. The business later expanded into a creamery, which became famous for its delicious Azalea brand ice cream. Mr. Berglin stands at the right, while his wife, Eva, and children pose in the surrey. (Courtesy Reed Myers.)

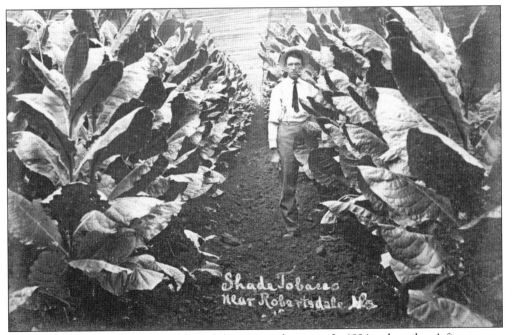

Tobacco grew in nearby Robertsdale and the surrounding area. In 1894—the colony's first year—a cigar factory shipped 800 "Fairhope" cigars to Chicago and Mobile for sale. The economic venture was short-lived, possibly because the local product was not that good 5¢ cigar everyone was hoping to find. (Courtesy Pinky Bass.)

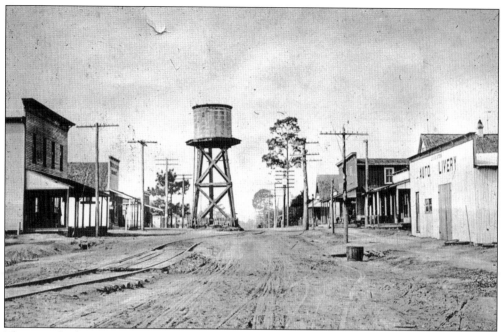

This view looking west toward the bay on Fairhope Avenue at Section Street shows the main mercantile corner about 1914 with the town water tank that replaced the well. By this time, Fairhope had its own electricity plant and home-owned telephone company in addition to a public waterworks and railroad venture. (Courtesy FSTC.)

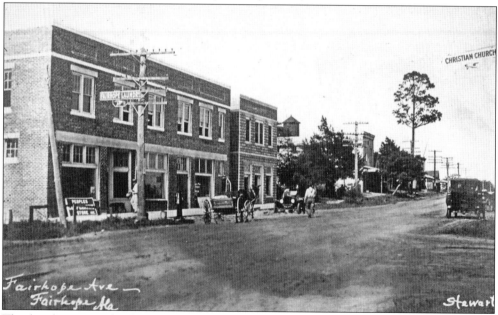

This handsome new brick Peoples Cooperative Store, completed in 1922, embodied Fairhope's ideals and carried everything from shoes to plowshares. Community meetings and Thursday afternoon forums were held in the spacious upstairs auditorium. The corner building at 310 Fairhope Avenue is still a hardware store. To its right was the town's furniture store, now a downtown restaurant building. (Courtesy Reed Myers.)

94

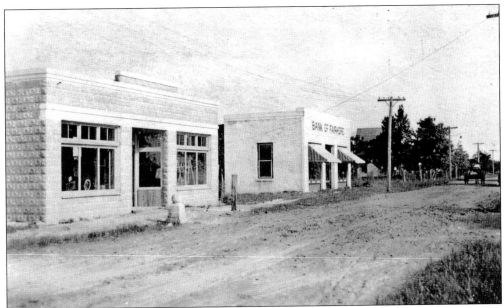

The Bank of Fairhope (right) at the corner of Section Street and Johnson Avenue was the town's first bank in 1917. It was the only county bank to weather the Great Depression, and the building now serves another business use. At left was the original 1924 Fairhope Coal and Supply at 31 Section Street. Later incorporated into a grocery market, it is now a dress shop. (Courtesy Fairhope Historical Museum.)

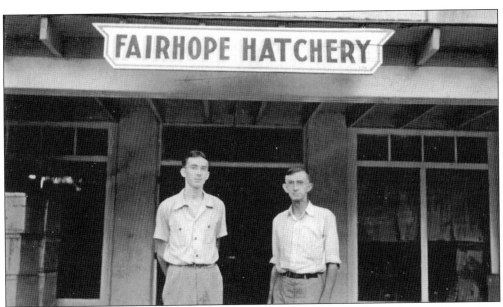

The Fairhope Hatchery occupied the Coal and Supply building from about 1929 to 1943. Operated by a prominent Quaker family, it hatched about 5,000 chicks a week. To the right is owner and early Fairhope settler Arthur Rockwell, and at left is his son and business partner Cecil. (Courtesy Cecil Rockwell.)

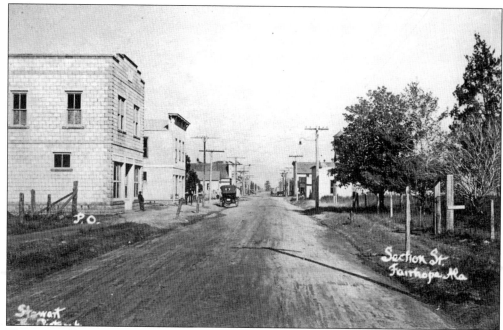

The post office and Greeno Masonic Lodge (far left) dominated Section Street, seen here looking north. The lodge at 66 South Section Street, built in 1911, was named in honor of Fairhope's first mayor, Dr. Harris S. Greeno, who donated the land for the building. Up the way was the Knights of Pythias Lodge. (Courtesy Fairhope Historical Museum.)

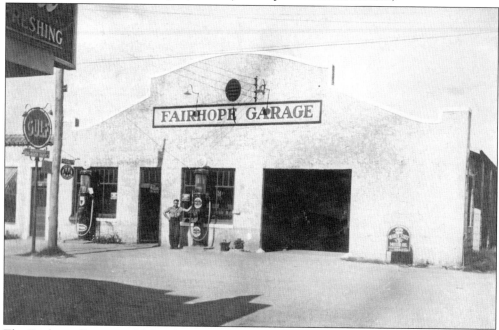

The Fairhope Garage at 25 South Section Street was built in 1924 and originally was a paint store. The building, with its distinctive contoured parapet, was built on the site of Fairhope's first school, which was in a small frame building. The building has served several commercial uses over its life, also housing a laundry and gift shop. (Courtesy Flora Maye Simmons.)

Called the "Pythian Castle" when dedicated in 1915, the former Knights of Pythias Fairhope Lodge still stands at 52 South Section Street, though heavily remodeled for business use since the lodge disbanded in the 1940s. The upstairs of the building, one of the few Pythian lodges in South Alabama, was also used for Fairhope Forum and Theosophical Society meetings. (Courtesy Rusty Godard.)

Arthur Mannich, center, stands in the early 1940s front of his Mannich's City Market and Grocery, which operated until about 1974 in downtown Fairhope. The building at 31 South Section Street has since housed several other businesses. Now the Colony Shop is located on the north side. (Courtesy Bob Mannich.)

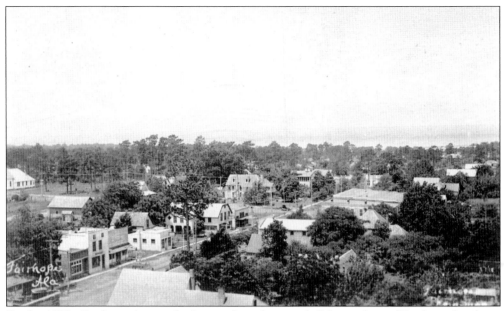

By the 1920s, Fairhope Avenue had everything but a jail. "No resident of Fairhope has been a defendant in a criminal case in county court. Perhaps I should add that there is no place except the county court where anyone could be a defendant; there has never been a court or jail or anything of that sort in Fairhope," wrote Upton Sinclair in "Enclaves of Economic Rent" in 1924.

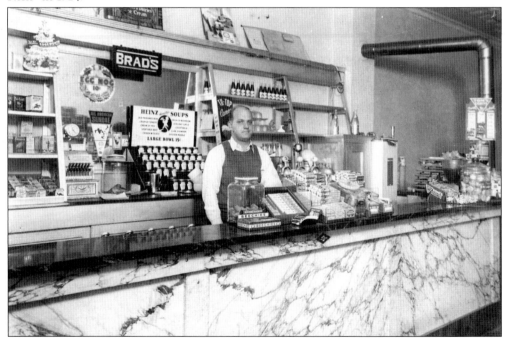

Ed Niemeyer tends the soda fountain in the late 1930s at Brad's, operated by his brother Brad. The popular eatery in the 1928 Walker Building at 384 Fairhope Avenue later became the Soda Garden. Shell's Five and Dime was next door. Today the restored building holds ground-floor specialty shops with business offices upstairs. (Courtesy Ken Niemeyer.)

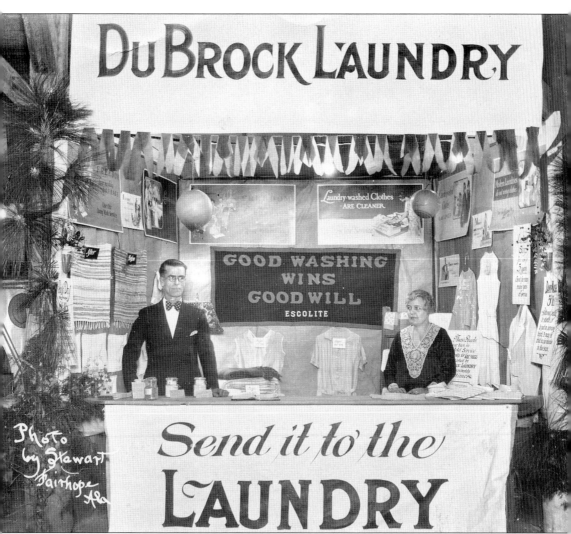

Norvin DuBrock and his wife, Sybilla, await customers at their laundry counter. DuBrock's Laundry operated for many years in the 1928 building at 7–11 North Church Street. The masonry building still features the remains of a brick furnace that helped fire the boilers for the steam-driven laundry equipment, which worked on a system of pulleys. (Courtesy George DuBrock.)

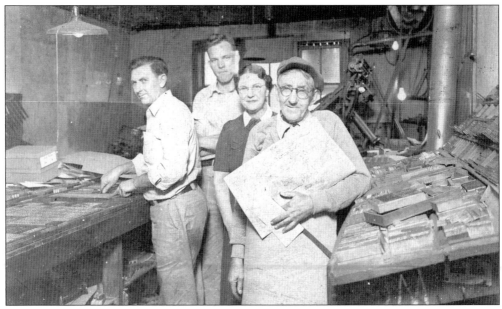

The *Fairhope Courier* staff works in the old newspaper make-up room at 336 Fairhope Avenue. They are, from left to right, Arthur Fairhope "Spider" Gaston; Henry Crawford; Henry's mother, editor Frances "Frankie" Gaston Crawford; and Ned Doughtery. The Gaston family published the influential newspaper from 1894, starting it in Iowa, until it was sold in 1964. (Courtesy Rusty Godard.)

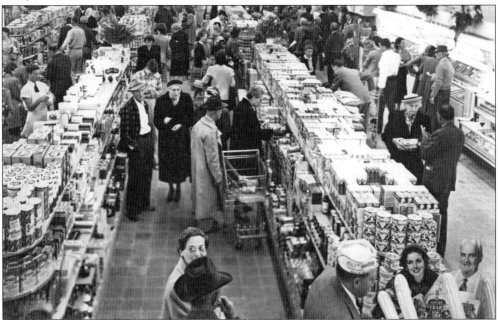

The town turned out for the opening of Greer's supermarket in the late 1940s at its new location on South Section Street. The original grocery first opened a block away about 1928 at 24 South Section Street, at the corner of Delamare Avenue. It was the first chain store in Fairhope, where the entire downtown business district has been nominated to the National Register of Historic Places.

Nine

CELEBRATION
AND DRAMA

We lived our little drama
We kissed in a field of white
And stars fell on Alabama last night

—"Stars Fell on Alabama," Mitchell Parish and Frank S. Perkins, 1934

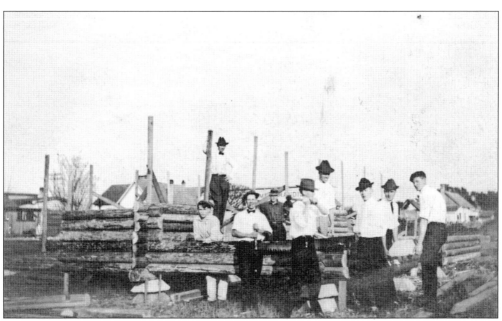

A group of young wags formed a semi-secret society called the Paw Paw Keewans and built their log clubhouse on a lane called Pig Alley. Calling themselves the PPKs, whose real meaning still remains a mystery, they enjoyed poking fun at the serious side of Fairhope, where many older residents attended meetings of organizations like the Henry George Club. (Courtesy Harriet Swift.)

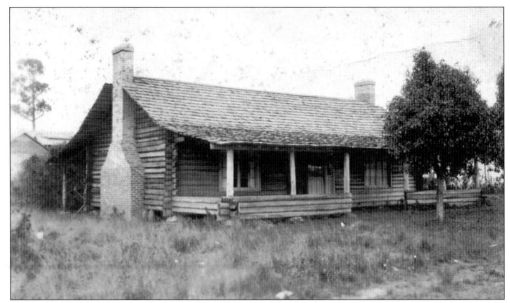

The completed PPK Club on Pig Alley, later renamed Delamare Avenue and now an upscale shopping district with antique and gift shops and art galleries, became a social center. The log cabin was the scene of dances, theatrical performances, and shows, such as a satire titled "Old Fairhope" presented by the PPK Minstrels. (Courtesy Flora Maye Simmons.)

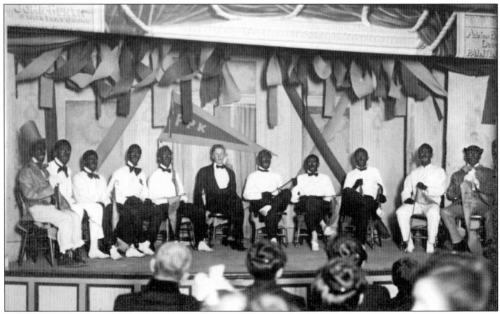

In 1916, the PPK Minstrels presented a locally written and produced show titled "Humble Yo'sef Brother, Humble Yo'sef." The back of this postcard said that some of the performers were from Hyde Park, Chicago, showing that seasonal visitors from out of town also participated in Fairhope productions. (Courtesy Reed Myers.)

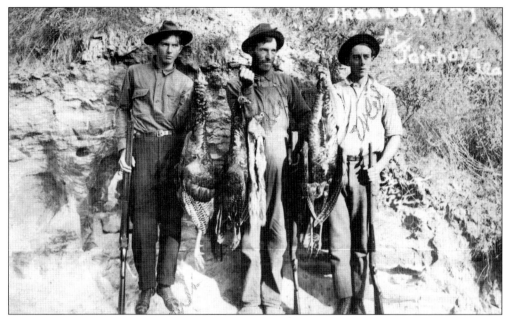

"Thanksgiving in Fairhope" is the title of this 1924 photograph of hunters returning from the turkey woods in nearby Spanish Fort with gobblers for the holiday tables. The three hunters displaying their game are, from left to right, Norris Stapleton, Harve Wilson, and Warren Stearns. (Courtesy Harmon Stearns.)

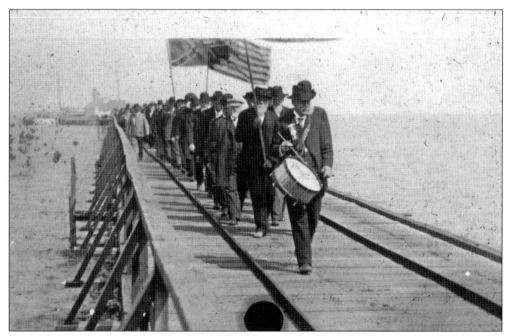

Civil War veterans arrived in Fairhope in January 1913 for the annual old soldiers reunion held in the town. Founded by people from different areas of the country, Fairhope was exceptional among small Southern towns in that it had more Union veterans than those who served on the Confederate side. (Courtesy FSTC.)

From the beginning, Independence Day called for picnics and a special community observance on the bay front. Here a group gathered on the steps, which still exist at the bluff park on South Mobile Street, to wave their flags for a Fourth of July celebration in the early 20th century. (Courtesy Pinky Bass.)

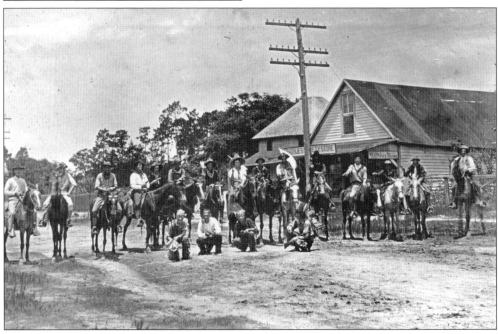

The 1906 Fourth of July celebration featured fireworks and a Buffalo Bill cowboy and Indians show sponsored by the firemen to attract visitors downtown. Hundreds of visitors used to come across the bay for Fairhope's doings on the Fourth, and today thousands come to watch the annual fireworks extravaganza produced by the Fairhope Volunteer Fire Department. (Courtesy FSTC.)

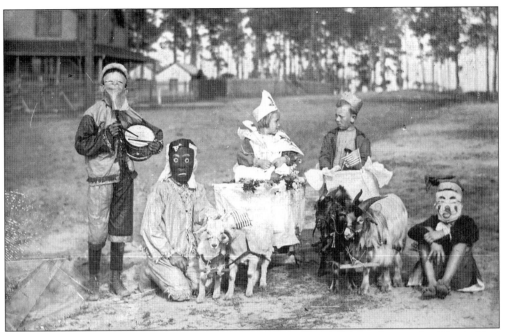

Several elaborate parades with floats move down Fairhope's streets during the Mardi Gras season. These costumed children in masks and crowns celebrated Fat Tuesday in 1908 by riding in carts. Fairhope's new arrivals were quick to take up the old Gulf Coast observation of Mardi Gras, which originated in Mobile, not New Orleans, which was founded later by the French. (Courtesy Robert Berglin.)

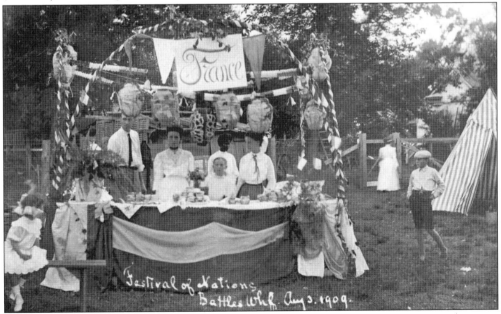

Fairhope was the kind of place where people got together to make elaborate and artistic floats and decorations for any occasion. Here a group of local residents participate in the Festival of Nations at nearby Battles Wharf in August 1909. Different floats were designed to honor the heritage of area settlers from other countries. (Courtesy Pinky Bass.)

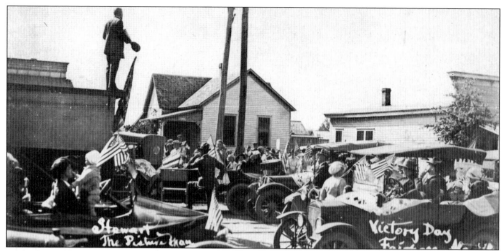

Fairhope mayor William McIntosh announces the end of World War I from atop a Fairhope Avenue building in an Armistice Day speech on November 11, 1919. McIntosh served two terms as mayor after moving to Fairhope in 1917 and helped organize the Bank of Fairhope. (Courtesy Flora Maye Simmons.)

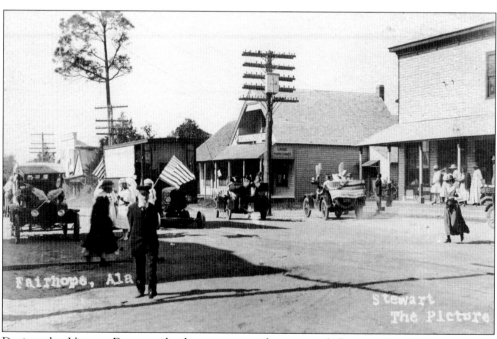

During the Victory Day parade downtown, residents waved flags, and vehicles, even the community rail car, were decorated with banners to celebrate the end of the war in which many Fairhope residents served. In the background is the Pinequat Shop, operated by the Call family. (Courtesy Marietta Johnson Museum.)

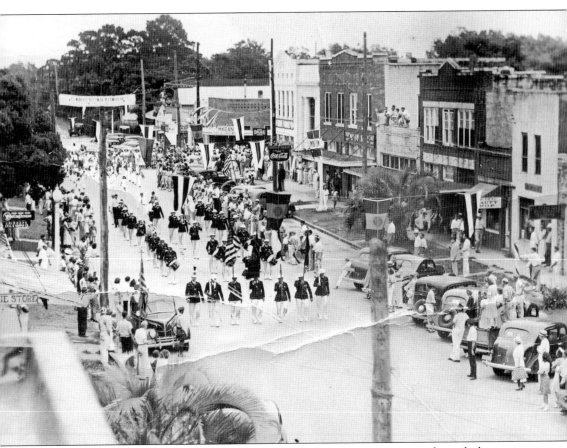

Fairhope, which still takes community pride in being a patriotic town, hosted the state convention of the American Legion in 1939. Here a parade marches down Fairhope Avenue, which was decorated and flying American flags in honor of the occasion. Some spectators watch from the top of a building at right. (Courtesy Ken Niemeyer.)

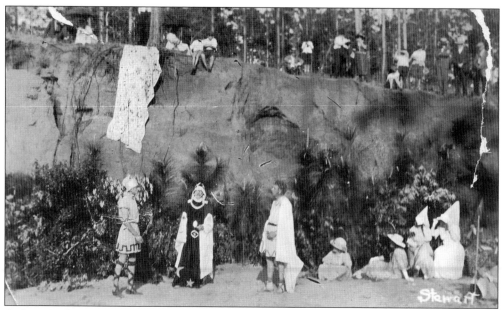

Only in Fairhope would most of the town turn out to watch a Shakespeare production where local actors would strut their moment on the stage—or in a gully, the town's natural amphitheater. The town held a dozen annual Shakespeare festivals, mostly during the 1920s, in honor of the English bard's birthday. (Courtesy Marietta Johnson Museum.)

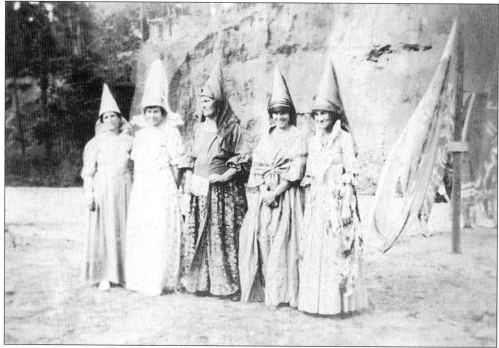

These fair ladies from Fairhope starred and sang in *The Taming of the Shrew*, presented in this outdoors setting in April 1929. The plays were produced and directed by Sarah Willard Hiestand, who had lectured and written textbooks on Shakespeare for Chicago schools before retiring with her husband to Fairhope. (Courtesy Warren Stearns.)

This Shakespearian thespian strikes a confident pose after a production. A critic of the day noted, "Some particular and precious spark is generated when neighbors come together to celebrate with dance and song and acting . . . some greatness." (Courtesy Marietta Johnson Museum.)

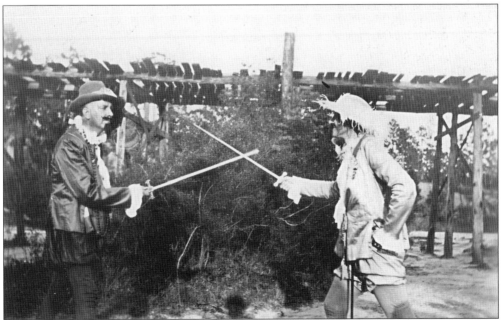

An old footbridge across one of the town's gullies serves as a dramatic backdrop for this sword-fight scene by two Shakespeare Festival players. There was no admission charge to the plays, which were presented as a gift. The productions also drew large audiences, including high school classes, from over the bay in Mobile. (Courtesy Claire Totten Gray.)

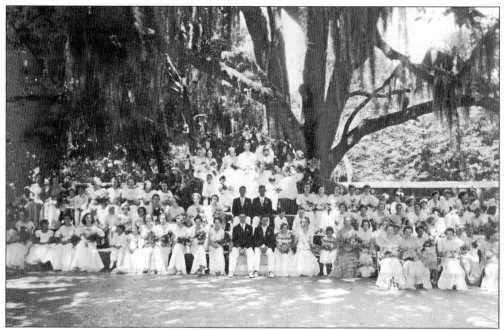

May Day was a special occasion every year when a queen was selected from lovely representatives of surrounding communities to preside over a court that gathered at May Day Park in Daphne, Fairhope's neighboring town. Not infrequently a Fairhope beauty was awarded the honor at the annual observance that began at Daphne Normal School. (Courtesy Flora Maye Simmons.)

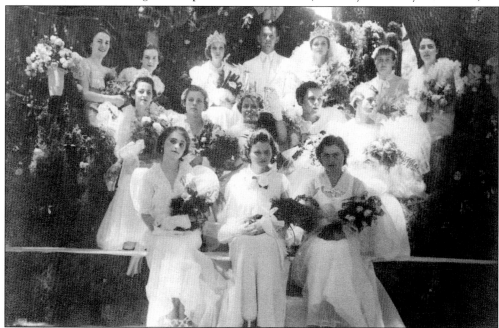

In the mid-1930s, the May Queen was Flora Maye Godard of Fairhope (third from left on the last row). Born in 1918, she has kept Fairhope's past and history alive with generous donations of her time and talents. She was a founder of the Fairhope Historical Museum, which contains artifacts, antiques, and historic photographs and documents she preserved.

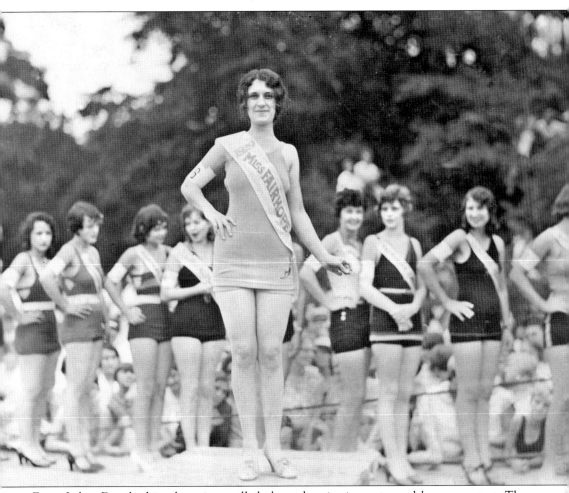

Every Labor Day, bathing beauties strolled along the pier in an annual beauty contest. The contestants gathered crowds of onlookers as they competed for the coveted title of Miss Labor Day. In 1929, the Miss Fairhope winner was Gladys Grimes, who daintily models a swimming suit fashionable for the time. (Courtesy Bob Mannich.)

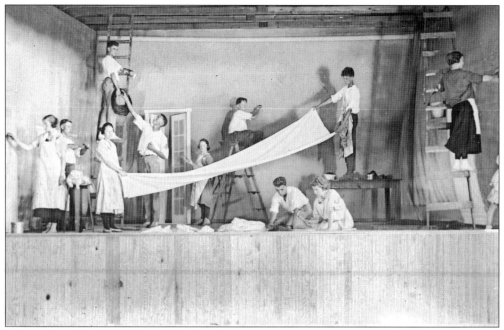

Drama and theater were part of life in Fairhope, even for the young. Students at the School of Organic Education take to ladders to paint scenery and hang backdrops for a play at the school, where part of the educational process was learning by doing. Today the Young Players produce annual shows at Theatre 98. (Courtesy Marietta Johnson Museum.)

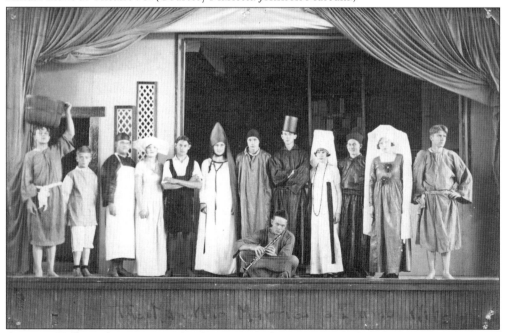

Comings Hall, on the Organic School campus at the corner of Fairhope Avenue and Bancroft Street, was the setting for many early theatrical productions. These Organic School students were in the cast of *The Man Who Married a Dumb Wife*, first produced in 1915. (Courtesy Marietta Johnson Museum.)

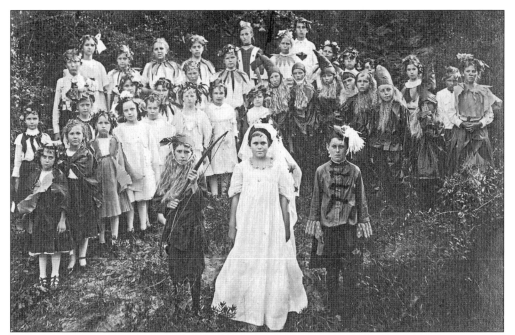

Young students at the Fairhope Public School turned out in style for a school play set in an outdoor sylvan scene. The title has been forgotten, but a prince and princess appear to have the lead in a fanciful tale featuring a cast of boys wearing homemade beards and girls in headdresses. (Courtesy Robert Berglin.)

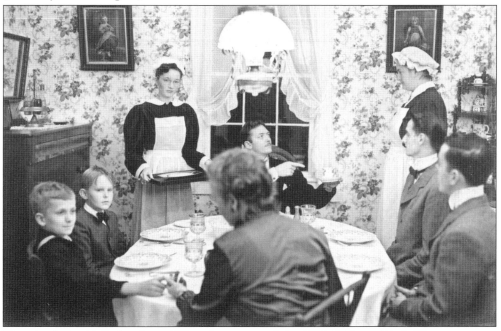

The play *Life with Father*, hot off Broadway, opened the 1947 Fairhope Little Theater season, directed by King Benton. Actors, from left to right, were Felix Bigby, Dan Benton, Ruby Eason, Helen Wilson (with her back to the camera), Dr. Andre Dacovich, Katie Myers, Vance Mason, and Bill Bell. (Courtesy Bill Bell.)

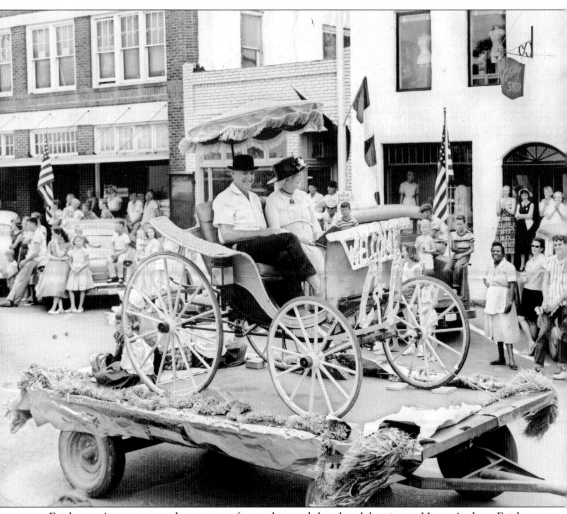

Fairhope Avenue was the scene of parades and local celebrations. Here Arthur Fairhope "Spider" Gaston and Helen Call, two of the first children born to single-taxer settlers after they arrived, are honored in 1958 during the town's Golden Jubilee celebration of its incorporation as a municipality 50 years earlier. (Courtesy Rusty Godard.)

Ten

FORGOTTEN FAIRHOPE

Here the streets of Fairhope were like none of the streets when she was a child
and they would visit—all these homes had sprung up since then,
none of the old waterfront homes survived, long gone, she had long ago mourned them
and now their own ghosts lay over the newer homes like veils, or mosquito netting.

—Brad Watson, "A Lost Paradise," from *The Heaven of Mercury,*
2003 National Book Award nominee

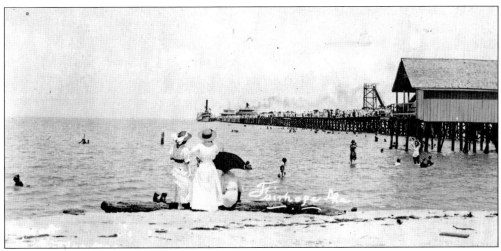

Ladies in white dresses on Fairhope's waterfront in 1912 are a reminder of sweeter times and simpler pleasures on the Eastern Shore. The shore is famed for a rare phenomenon called Jubilee, where fish, crab, shrimp, and other sea life come to the shallows in certain weather conditions. At the cry of "Jubilee!" everyone grabs a net and heads to the bay. (Courtesy Palmer Hamilton.)

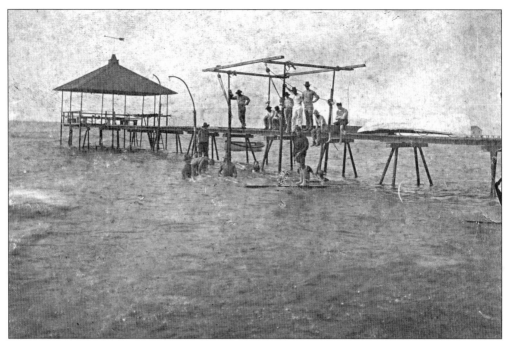

Volunteers work on building another pier house on the bay. Many waterfront homes and several streets, like Orange, Pier, and White, that end at the public park along the bay have their own piers. The rustic wooden public piers are used by boaters, swimmers, fishing parties, and for watching sunsets. (Courtesy FSTC.)

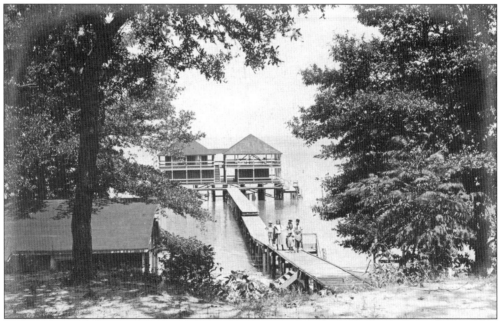

"Beyond the hotel, piers ran from the old summer homes out over the bay. Most of them had a pier house or a handmade lean-to at the end, so a family could sit out on summer nights," wrote author and former Fairhope resident Mark Childress in his 1988 novel *V for Victor*, which was set in the area. (Courtesy Fairhope Historical Museum.)

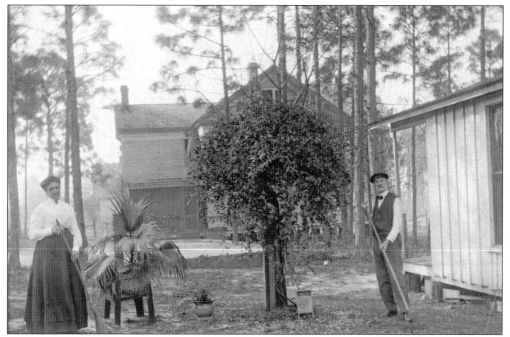

In Fairhope, which features the Marietta Johnson Botanical Garden downtown, gardens have always been the pride of many of their owners, who have created lush, private backyard retreats. Here Mr. and Mrs. Summner are preparing to plant a palm behind their cottage on Bayview Avenue in the early part of the century. (Courtesy Pinky Bass.)

At the Snug Harbor guesthouse that once stood on Magnolia Avenue, the owners proudly tend their fruit trees. Many of the towering trees lining Fairhope's streets were planted in the early 20th century, when residents were given a financial incentive of 25¢ for every water oak tree they planted. (Courtesy Pinky Bass.)

Originally a Baptist church, the former St. James Episcopal Church building served the congregation from 1920 to 1994 and is now the University of South Alabama auditorium on its Fairhope campus. Here Stephen Riggs and Aline Stapleton emerge from the church after their 1940s wedding. To the right is best man Curtis Willard. (Courtesy Aline Stapleton Riggs.)

Weddings were social events where everyone in town was welcomed. These bridesmaids dressed in elegant attire with matching slippers were attendants at a Fairhope wedding at the beginning of the 20th century. Seated is Anna Linder Anderson, and standing is Gudren Erickson Swanson. (Courtesy Pinky Bass.)

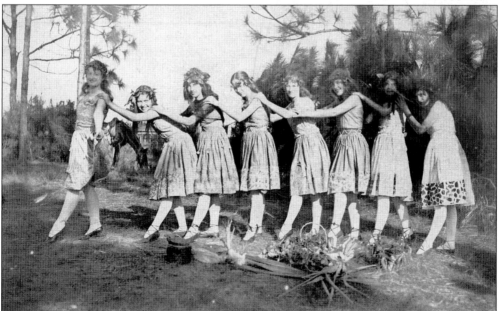

These graceful dancing girls, students at the School of Organic Education, look like playful wood nymphs while performing a dance among a backdrop of pines. Outdoor activity has always been a part of the lifestyle in Fairhope, where today there are street dances and concerts on the bluff. (Courtesy Marietta Johnson Museum.)

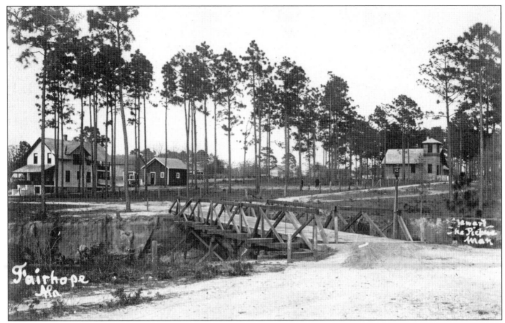

The wooden bridge on South Bayview Avenue across Stack's Gully facilitated movement across the town, which grew up along a shoreline interspersed by deep ravines. Early on, this main gully was cleared for public use, but later kudzu, that irrepressible vine planted across the South, was used to stop erosion in the gullies and along the bluffs.

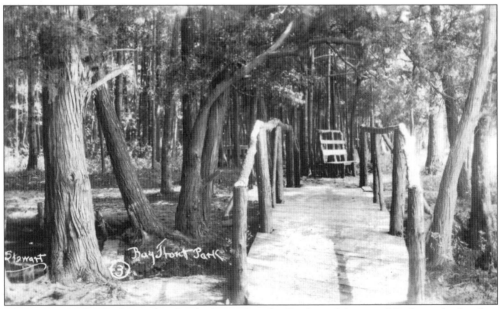

This romantic footbridge across the duck pond at the Fairhope Municipal Park on the bay has been replaced by a newer one, but it is still an inviting spot for weddings, picnics, and feeding the waterfowl. The area also now features the Beach Park Tree Trail, which identifies trees, including two state champions—swamp tupelo and hazel alder. (Courtesy Reed Myers.)

Fairhope has several state champion trees, including a flowering crepe myrtle in the heart of downtown. This view of a woman admiring a beautiful dogwood shows why the New Year's 1895 issue of the *Fairhope Courier* reported the village site was "one of the most beautiful and desirable spots along the whole Eastern Shore of Mobile Bay." (Courtesy Claire Gray.)

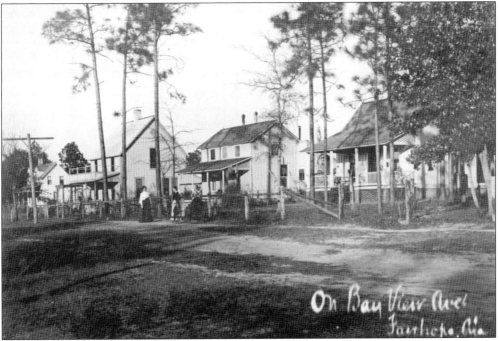

Neighbors linger to visit on a leisurely walk along North Bayview Avenue. Residents carried lanterns on their promenades in the evenings in the years before the town got streetlights. These landmark homes are still standing on the east side of Bayview in the first block off Magnolia Avenue. (Courtesy Barbara Beaty.)

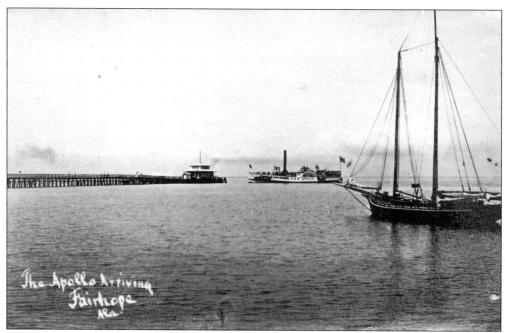

The side-wheeler *Apollo*, with room for 540 passengers, arrives at the Fairhope pier. In 1912, local private investors purchased the steamer in New York to make the run across the bay to Mobile and back. Founders selected the waterfront site to provide a good trading and shipping point. Even then, times were changing, with sailing vessels being used mostly for fishing. (Courtesy Barbara Beaty.)

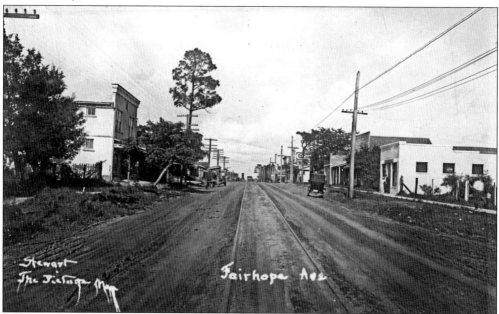

Rathje's store on the left, in this view looking east on Fairhope Avenue, issued its own metal scrip, which was used in exchange for goods. This new general store, built in 1914 to replace the earlier wooden structure next door, sold a bit of everything, including violin string. The building still stands at 331 Fairhope Avenue. (Courtesy Cathy Donelson.)

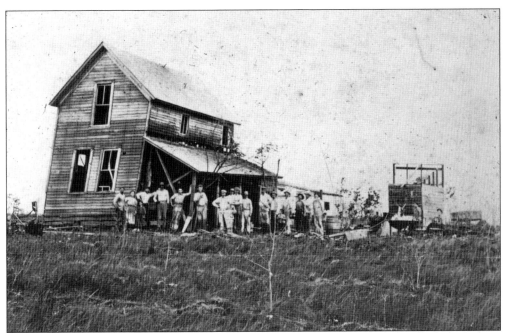

Hurricanes were and are a potent force and fact of life on the coast. The hurricanes of 1906 and 1916 were particularly destructive in Fairhope, destroying steamers and boats and knocking houses off their foundations. Afterward house-raising crews gathered to help repair buildings and barns hard hit by the high winds. (Courtesy FSTC.)

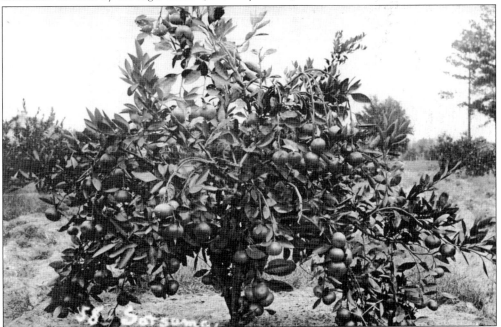

Satsuma oranges were a tasty citrus treat, and most Fairhope home sites had a fruit tree in the yard. Many farmers were members of the Citrus Growers Association, and Fairhope shipped tons of the fruit by boat and rail to other areas of the country in crates made at the local sawmill. Residents also sent fruit to Northern friends. (Courtesy Reed Myers.)

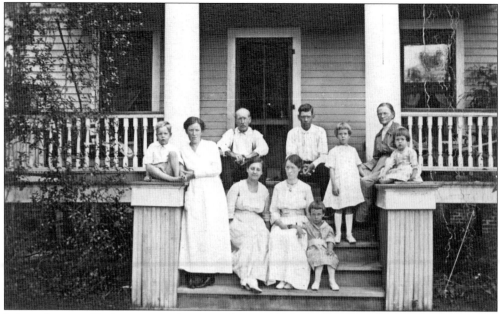

Leisure hours in Fairhope were often passed in simple pursuits like spending time with family on the front porch. Here three generations of Sundbergs and Slossons gather at the Columns at the corner of Magnolia and Bayview Avenues. Fairhope once was a town of porches, and many homes had sleeping porches across the back. (Courtesy Pinky Bass.)

Children roamed the bay front and played in the streets and gullies unsupervised in the days when everyone knew everyone else in the village. They walked and ran everywhere, and some rode, like young Philip Swift on his pet donkey. (Courtesy Harriet Swift.)

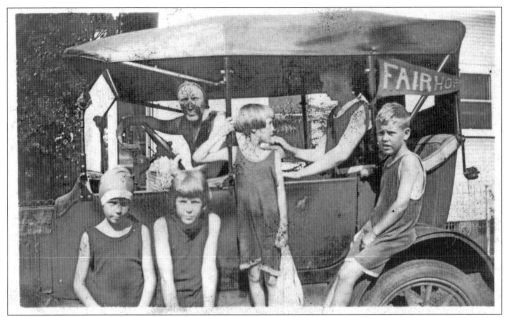

Cars became a fixture on Fairhope streets after the bay boats started catering to automobile traffic, landing vehicles on the pier. Visitors brought cars by boat until the causeway was built across Mobile Bay in 1926 and the steamers stopped running to Fairhope. Here the Sundberg family heads out for a swim in the family car, which displays a Fairhope pendant. (Courtesy Pinky Bass.)

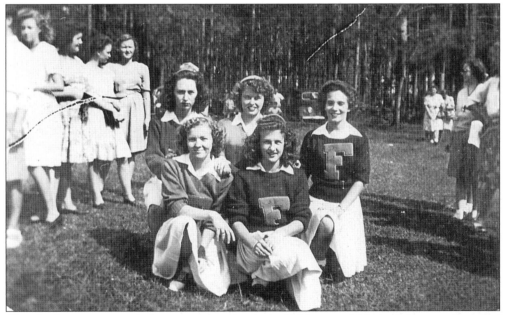

Cheerleaders encouraged the teams at schools in Fairhope, which had its own brand of boosterism. In a 1926 article about the new high school, the Mobile newspaper reported, "Fairhope claims to be the most cosmopolitan village in the world, attracting people of intelligence and progressive thought, as the pole attracts the needle of the compass." (Courtesy Marietta Johnson Museum.)

Despite its modest beginnings, Fairhope was always fashionable. Here Lois Slosson Sundberg poses in a striking black ensemble complete with picture hat. She was pictured earlier with her school students. Fairhopers were well traveled, and visitors also brought the latest styles to town. (Courtesy Pinky Bass.)

Life in the reformist town had its lighter moments. Here John W. Ettel, a New Yorker and Socialist for whom Ettel Street is named, dressed down on purpose. He jokingly posed for this photograph to send to a friend to show him how hard his wife was making him work in Fairhope. (Courtesy Pinky Bass.)

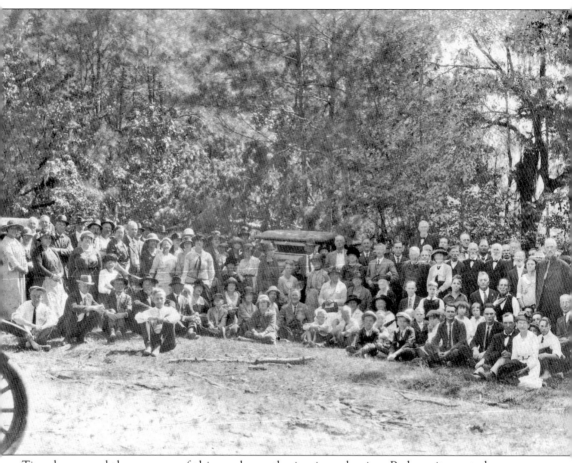

Time has erased the purpose of this somber gathering in a clearing. Perhaps it was to honor the gentleman seated in the foreground? The group surely included members of many organizations listed in the 1915 town directory, such as the Equal Suffrage Association and the Fairhope Socialist Local, which met on Friday nights at the country club, of all places. (Courtesy Rusty Godard.)

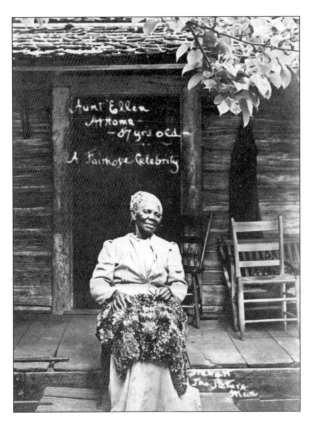

An older Ellen Hill lived for over half a century at Sea Cliff, where her cabin became a mecca for tourists who enjoyed her stories of the "old days." She liked to sit on her porch, knitting lovely rugs and watching the ships in the bay, until her death in 1920. (Courtesy Bill Payne.)

Lavigne Berglin and friend display a prize alligator gar caught in 1914. As Fannie Flagg wrote in *Fried Green Tomatoes at the Whistle Stop Café*, written in Fairhope: "P. S. If any of you ever get to Fairhope, Alabama, look us up. I'll be the one sitting on the back porch, cleaning all the fish." (Courtesy Robert Berglin.)